GLOBAL
ART

ART ESSENTIALS

GLOBAL ART

—

JESSICA
LACK

—

CONTENTS

INTRODUCTION

The art movements in this book come from all over the world and were established for a myriad of reasons – be they aesthetic, political or conceptual. What unites them, if anything, is a clear-eyed recognition of the broken social orders in which they were operating and a realistic fear of what might come to pass if they did nothing. As Prodosh Dasgupta, founder member of the Calcutta Group, wrote: 'The artist could no longer be blind to his age and surroundings.'

Of the fifty featured, some emerged fully formed with rhetoric so powerful they seethed with the pugnacious energy of a prizefighter, but the majority came together as loose associations of artists with similar progressive ideals that sought to challenge the status quo through their collectivity. Some gave themselves names, while others were only named in retrospect by theorists and historians keen to give form and definition to a cultural phenomenon.

Because of the distinct geographical, aesthetic and political circumstances of each movement, it has been necessary to offer some historical background. As the artist Keith Piper highlighted in relation to the Black Arts Movement in the 1980s, the biggest danger of studying an art movement is to study it outside of its cultural and political context as separated 'from the real-life social unrest that was being played out on the streets'.

The theorist Stuart Hall wrote extensively about our need to broaden our horizons away from the traditional centre-periphery relationship in favour of multiple centres of interconnectivity. These art movements, which range from the anti-colonial philosophy of the Bengal School of the 1900s to the rallying cry of Black Lives Matter in 2012, will, it is hoped, go some way in expanding those horizons and our knowledge of the history of art.

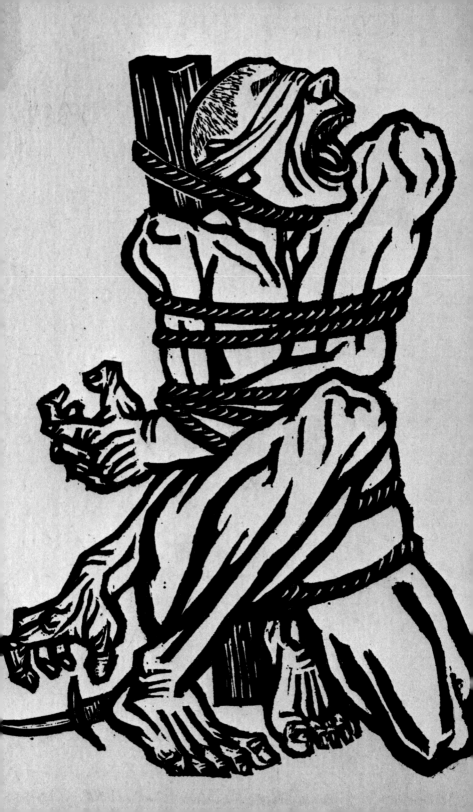

IMPERIALISM
AND REVOLUTION

-

Let us rise up! With our raging passion and iron intellect, we will create a world interwoven with colour, line and form!

-

The Storm Society, 1932

BENGAL SCHOOL
c.1899–1930

In 1909 the Sri Lankan cultural theorist Ananda K. Coomaraswamy wrote a controversial manifesto entitled *Art and Swadeshi*, voicing support for the revival of an all-Indian culture to counter British imperialism. He wrote:

> It is the weakness of our national movement that we do not love India; we love suburban England, we love the comfortable bourgeois prosperity that is to be some day established when we have learned enough science and forgotten enough art to successfully compete with Europe.

The call-to-arms was inspired by political events that began in the northeast Indian province of Bengal in the late 1800s, where the struggle for Indian independence was at its most critical.

Abanindranath Tagore
Journey's End, 1913
Ink wash and tempera on paper, 15 x 21 cm
(5⅞ x 8¼ in.)
National Gallery of Modern Art, New Delhi

Tagore is often described as a Symbolist, for his lyrical images that drew on Hindu mythology. His mastery of Japanese ink-wash techniques contributed to the dreamlike quality of his paintings.

At the cultural centre of the debate was the Government School of Art in Calcutta (now Kolkata), where the school's director Ernest Binfield Havell urged his students to take inspiration from Mughal, Rajasthani and Pahari art rather than western art. Traditional Indian painting had fallen out of fashion during the British Raj, partly because the techniques were not taught in the academies and also because British collectors were only interested in buying an exoticized form of Indian painting.

The new movement was known as the Bengal School and it advocated a mystical modern art immersed in the rich heritage of the ancient Mughal and Rajput artistic traditions.

Two key artists of the new school were Sunayani Devi and Abanindranath Tagore, the niece and nephew of the Bengal Renaissance poet, artist and thinker Rabindranath Tagore. They promoted a pan-Asian outlook that drew on influences from across the wider continent, in particular ink wash from Japan, which was introduced to Tagore by the artist Okakura Kakuzö. Many of the artists of the Bengal School were committed social reformers who went on to promote the movement's romantic style in art schools and establish educational programmes across the country that advocated an all-Indian art.

One of the main exponents was the artist Nandalal Bose, who had studied with Tagore. He took his inspiration from Indian mythology and Buddhist cave paintings and applied these styles to depictions of daily life, creating works of startling originality.

In the 1920s he met Mahatma Gandhi, and began producing paintings in support of the lawyer's nonviolent resistance movement. His sketches and prints of Gandhi, particularly those made during the activist's twenty-six day march in 1930 in protest against the

salt tax, depicted the leader as a humble, but resolute, servant
of the people. The images were crucial in mythologizing the
anti-colonialist as a steadfast, unifying force.

KEY ARTISTS

Nandalal Bose (1882–1966), India
Sunayani Devi (1875–1962), India
Manishi Dey (1909–66), India
Asit Kumar Haldar (1890–1964), India
Jamini Roy (1887–1972), India
Abanindranath Tagore (1871–1951), India
Gaganendranath Tagore (1867–1938), India

KEY FEATURES

A naturalist romantic style • Mystical subject matter – scenes
from *The Arabian Nights*, the Sanskrit epic *The Ramayana*
and Indian poetry • Inspired by Mughal miniatures and Japanese
ink-wash painting

MEDIA

Painting • Printing

KEY COLLECTIONS

National Gallery of Modern Art, Mumbai, India
National Gallery of Modern Art, New Delhi, India
Victoria Memorial Hall, Kolkata, India

Sunayani Devi
*Untitled (Lady with
Parrot)*, c.1920s
Watercolour and pencil
on paper, 32.3 x 32.3 cm
(12¾ x 12¾ in.)
Private collection

**A chronicler of the
domestic interior,
Sunayani Devi is
credited as being the
first modern artist to
champion traditional
Bengali folk art.**

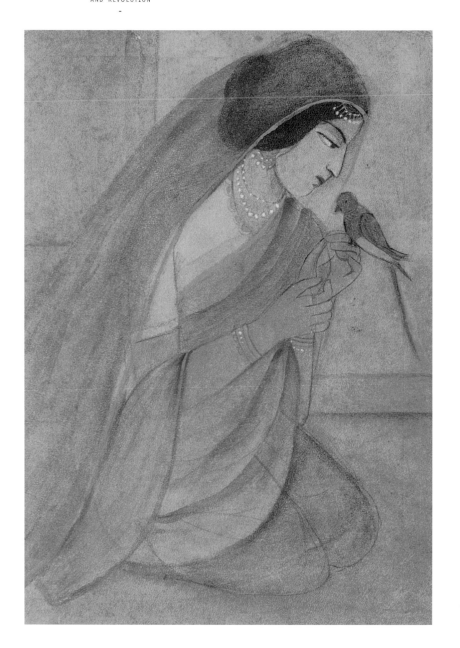

STRIDENTISM
1921–7

One night in December 1921, a manifesto appeared on the walls of Mexico City, its rhetoric so provocative it seemed to seethe with the pugnacious energy of a prizefighter. Written by a young, subversive poet called Manuel Maples Arce, *Now: No. 1. Manuel Maples Arce's Flyer of the Avant-Garde Stridentist Pill* was a combative appeal to Mexican intellectuals to reject the past and confront the present time.

'Death to Father Hidalgo, Down with San Rafael and San Lázaro,' wrote the poet, referring to the great hero of Mexican independence and two revered saints. The text also quoted from Filippo Tommaso Marinetti's Futurist manifesto of 1909: 'An automobile in motion is more beautiful than the Victory of Samothrace.' This was the birth of Stridentism (Estridentismo), a literary and artistic movement that incorporated European modernist trends with Mexican art nouveau and art deco.

Opposite: Lola Cueto
India Oaxaqueña, 1928
Tapestry, 118 x 74 cm
(46¼ x 29⅛ in.)
Private collection

The artist and puppeteer, Lola Cueto, was one of the few women artists at the centre of Stridentism. A committed social reformer, she took her inspiration from Mexican folk art and Pre-Columbian traditions. She founded a puppet theatre in order to stage educational stories for deprived children.

Leopoldo Méndez
Little Teacher, How Immense Is Thy Will!, 1948
Linoleum cut on beige paper, 30.6 x 41.6 cm
(12 x 16⅜ in.)
Brooklyn Museum of Art, New York

This linocut by Leopoldo Méndez appeared in the socialist film *Río Escondido* (1948). The artist was a great champion of the cinema, which he considered a valuable resource in disseminating the Stridentist message. He described film as 'moving murals'.

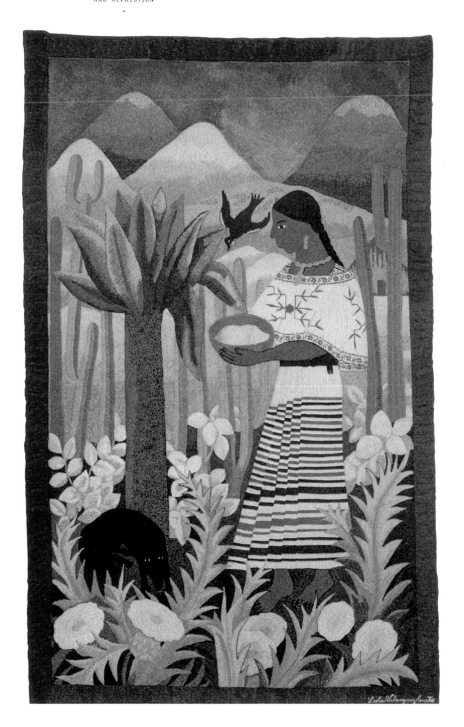

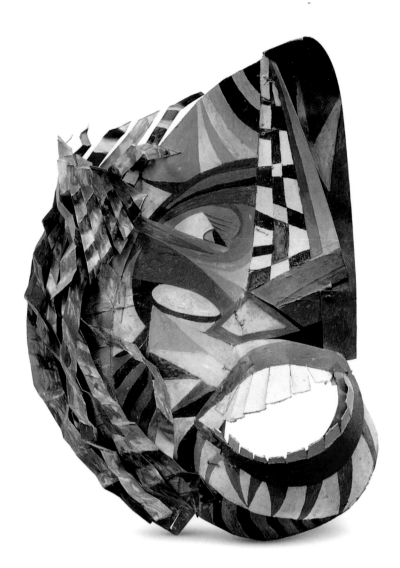

Maples Arce had been in contact with many of the European avant-garde – Marinetti had sent him Futurist pamphlets, and he had been inspired by the modernist poetry of French writers such as Blaise Cendrars and Pierre Reverdy. What united the group was their celebration of the urban environment and their political affiliations with the left.

Germán Cueto
Másara I (Mask 1), 1924
Painted cardboard,
43 x 23.5 x 18.5 cm
(16⅞ x 9¼ x 7¼ in.)
Private collection

Together with his wife Lola, sculptor Germán Cueto was at the centre of Mexico's revolutionary avant-garde. Cueto's theatrical semi-abstract masks were inspired by Pre-Columbian art, and many depicted figures in the Mexican intelligentsia, raising questions about high and low culture.

They participated in workers' demonstrations, and held Stridentist evenings featuring poetry readings and painting exhibitions, yet unlike their fellow artists in the Mexican Muralist Movement, they were not interested in the creation of new national identity through art. The Stridentists refused to romanticize the Mexican Revolution, preferring to confront the social realities of their country with a cold, hard clarity. The printmaker Leopoldo Méndez made woodblock prints to illustrate Stridentist books, while others, such as Ramón Alva de la Canal, painted images that celebrated the technological advances of contemporary urban life, such as the aeroplane, the telegraph and the radio. They were pro the Russian Revolution and believed that they could change society by inventing new forms of expression.

Between 1925 and 1927 the Stridentists lived communally in a house in Xalapa, Veracruz, supported by the revolutionary General Jara, from where they also published the magazine *Horizonte*. The movement ended in 1927, when Jara was deposed and the offices of *Horizonte* attacked and books and artworks burned. The Stridentists escaped and went their separate ways, but continued to promote their socially inclusive agenda for the rest of their lives.

KEY ARTISTS
Ramón Alva de la Canal (1892–1985), Mexico
Jean Charlot (1898–1979), France–US
Germán Cueto (1893–1975), Mexico
Lola Cueto (1897–1978), Mexico
Leopoldo Méndez (1902–69), Mexico

KEY FEATURES
Heroic subject matter • Abstraction • Use of line and form to convey excitement • Emotional, sometimes mystical or spiritual vision • Exaggerated imagery • Existential

MEDIA
Painting • Sculpture • Linocut and woodblock printing

KEY COLLECTIONS
Museo Nacional de Arte, Mexico City, Mexico

ZENITISM
1921–30

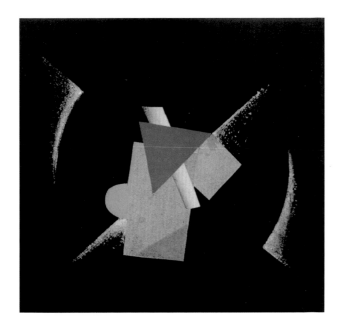

Zenitism was an anti-rational art movement founded in 1921 by the Serbian poet Ljubomir Micić with the publication of the first issue of *Zenit* magazine. The aim was to bring together a relatively loose group of young artists and writers (Zenitists) from Zagreb and Belgrade to promote a universal, humanist avant-garde art. They were irascible, paradoxical and refuted every tradition going. They extolled the new: at first German Expressionism, followed by Dadaism and post-war Italian Futurism and Constructivism. Micić argued that Europe's ailing culture in the wake of the First World War could only be revived by barbaric means. To this end he conceived of an Eastern European superman, a 'barbarogenius' who would bring a new primitive spirit to the continent.

In 1926 Micić was threatened with imprisonment after publishing a provocative article in *Zenit* that praised Bolshevism. The Italian Futurist Filippo Tommaso Marinetti helped Micić and his wife, the writer Anuska Micić, move to Paris. Without its charismatic leader, Zenitism lost momentum; nevertheless its uncompromisingly modernist ideas continued to inspire artists in the region.

Jo Klek
Pafama, 1922
Collage and pastel,
22.6 x 31 cm
(8⅞ x 12¼ in.)
Museum of
Contemporary Art,
Zagreb

The artist Jo Klek, whose watercolours and collages were partially inspired by Constructivism, came to represent the *Zenit* style.

KEY ARTISTS

Dragan Aleksić (1901–58), Serbia
Helene Grünhoff (1880–?), Russia
Jo Klek (1904–87), Croatia
Mihailo S. Petrov (1902–83), Bulgaria
Branko Ve Poljanski (1898–1940), Croatia

KEY FEATURES

Abstract, geometrical forms • Expressive line and form •
Political, utopian and experimental • Absurdist

MEDIA

Print • Collage • Watercolour • Pastel • Painting

KEY COLLECTIONS

Marinko Sudac Collection, Sabreb, Croatia
Museum of Contemporary Art, Belgrade, Serbia

Cover design for *Zenit*,
no. 17–18 (Zagreb, 1922)
Private collection

The magazine *Zenit*,
which was Marxist in
sympathy, published
articles and artworks
by the radical artists,
writers and architects
of the period, including
Pablo Picasso, Wassily
Kandinsky, Walter
Gropius and Boris
Pasternak.

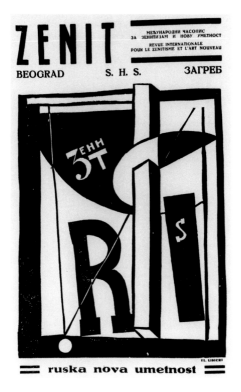

AFROCUBANISMO
c.1927–40s

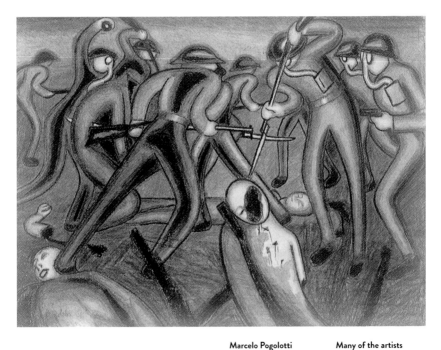

Marcelo Pogolotti
*Business is Good
(Hand-to-hand)*, 1931
Pencil and crayon on
paper, 28.9 x 40 cm
(11⅜ x 15¾ in.)
Museo Nacional de Bellas
Artes de Cuba, Havana

Many of the artists
associated with
Afrocubanismo were
politically active. This
drawing comes from a
series of artworks that
challenged the rise
of capitalism and the
erosion of workers' rights
in Cuba. Pogolotti lost
his sight at thirty-six, and
subsequently became a
renowned Cuban writer.

Afrocubanismo was a cultural movement with Marxist sympathies that emerged in Havana in the mid-1920s. It was founded by artists, writers and composers who sought to create a Cuban identity based on the island's African and Spanish heritage. Until this moment, African-influenced art had been virtually ignored by Cuban society, but now artists, musicians and writers were becoming receptive to the democratizing aspects of black street culture.

The movement began during a period of economic and political crisis under President Gerardo Machado, who brutally suppressed opposition to his rule. Following a manifesto written by the cultural activist Grupo Minorista in 1927, which called 'for popular art and, in general, new art in all its diverse forms', intellectuals seized the moment of nationalist sentiment following Machado's departure in 1933 to promote their inclusive agenda. They recognized the empowering possibilities of dance, performance and music in giving voice to the oppressed.

Teodoro Ramos Blanco
Vida Interior
(*Interior Life*), 1934
30 x 17 x 23.5 cm
(11¾ x 6¾ x 9¼ in.)
Museo Nacional de Bellas
Artes de Cuba, Havana

**This head is almost
mystical in its
introspection and
a far cry from the
stereotypical depictions
of black culture for
which Afrocubanismo
is sometimes criticized.**

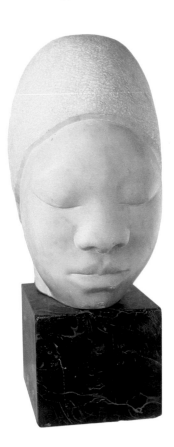

Afrocubanismo combined avant-gardist tendencies happening in Europe and America, such as jazz, Cubism and Expressionism, with Cuba's Spanish Baroque style and black street culture. Much of the artistic output was instigated by the white, middle classes of Cuba, which has led to criticisms of racial stereotyping and trivializing the marginalization of the country's black community, but others, including the historian Alejandro de la Fuente, have argued that both white and Afro-Cuban intellectuals recognized this as a critical moment in which to highlight the endemic racial, economic and social inequalities in the country. Poet Nicolás Guillén combined the speech, legends and songs of Afro-Cubans in his literary masterpiece *Motivos de Son* (*Motifs of Son*; 1930), while artists, such as Teodoro Ramos Blanco, sought to create a genuine national culture in which blackness was not reduced to decoration or exoticism. When the painter Wifredo Lam returned to his native country from war-torn France in the 1940s, he responded to Afrocubanismo by producing perhaps his most famous painting, *La Jungla*.

Amelia Peláez
Fishes, 1943
Oil on canvas, 114.5 x 89.2 cm (45⅛ x 35⅛ in.)
Museum of Modern Art (MoMA), New York

Having studied in Paris where she encountered Cubism, Peláez sought to create a synthesis between modern abstraction and Cuba's creole culture.

KEY ARTISTS
Eduardo Abela (1889–1965), Cuba
Teodoro Ramos Blanco (1902–72), Cuba
Wifredo Lam (1902–82), Cuba
Amelia Peláez (1896–1968), Cuba
Alberto Peña (1897–1938), Cuba
Marcelo Pogolotti (1902–88), Cuba
Jaime Valls (1883–1955), Cuba

KEY FEATURES
Use of bold colour • Multiple perspectives • African art influences • Forms fragmented into geometric patterns • Cuban folk traditions

MEDIA
Sculpture • Oil paintings

KEY COLLECTIONS
Museo Nacional de Bellas Artes de Cuba, Havana, Cuba

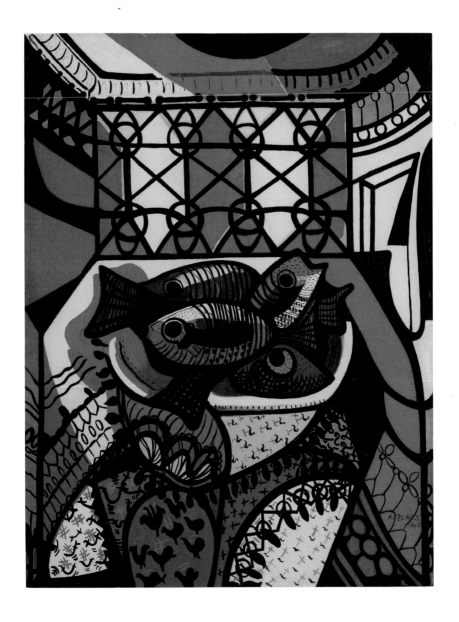

ART OF THE NEW CULTURE MOVEMENT
1920s–30s

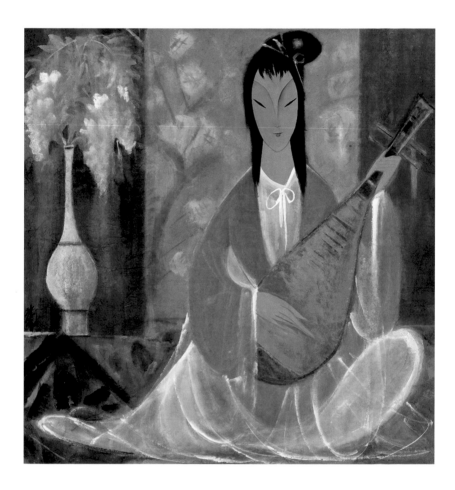

Before the advent of communism in China, there was a short-lived moment of fragile liberalism in the 1920s and early 1930s. This era saw the establishment of a number of avant-garde art groups that grew out of a desire by young intellectuals for a cultural renaissance in the arts. This became known as the New Culture Movement. The Xinhai Revolution of 1911, which overthrew the imperial dynasty, kick-started a programme of social and economic reforms in China,

and now artists argued that this modernization should be artistic too. In 1928 the charismatic painter Lin Fengmian – the foremost artist of his generation – established the Art Movement Society in Hangzhou, which agitated for a pan-Asian art that also looked to the radical avant-garde practices happening in Europe. The results were paintings that integrated Chinese and western aesthetics, experimenting with perspective and colours rarely seen in Chinese painting before.

A few years later, in 1931, the Shanghai-based Storm Society (Juelanshe) went one step further, provocatively articulating their desire to 'hit the rotten art of contemporary China with a powerful wave'. Inspired by anti-rational art movements such as Dada, artists combined the colour and brushwork of western oil painting with the decorative aspects of Chinese art. Yet these nascent artistic experimentations were eventually crushed beneath the juggernaut of Maoist ideology in the 1940s, and the onset of the Cultural Revolution in 1966. Lin Fengmian was imprisoned and much of his work destroyed, while Storm Society founder Ni Yide is thought to have died, possibly of torture, during the Cultural Revolution.

Lin Fengmian
Lady Playing Pipa,
c.1950s–60s
Ink and colour
on paper, 69 x 68 cm
(27⅛ x 26¾ in.)
Private collection

Fengmian attempted to reconcile Chinese art practices with European ones. This painting reveals his interest in Matisse portraits.

KEY ARTISTS

The Art Movement Society:
 Li Puyuan (1901–56), China
 Lin Fengmian (1900–91), China
 Lin Wenzheng (1903–89), China
The Storm Society:
 Ni Yide (1901–70), China
 Pang Xunqin (1906–85), China

KEY FEATURES

An integration of eastern and western aesthetics • Expressive use of colour, line and form • Multiple perspectives • Bright palette and rough brushstrokes • Decorative surfaces

MEDIA

Oil painting • Chinese ink drawing

KEY COLLECTIONS

Hong Kong Museum of Art, Hong Kong, China
Jiangsu Provincial Art Museum, Nanjing, China
Metropolitan Museum of Art, New York, NY, USA
National Art Museum of China, Beijing, China

MODERN WOODCUT MOVEMENT
c.1927–37

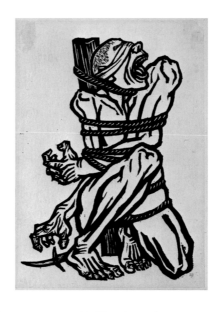

Li Hua
China, Roar!, 1935
Woodcut, 23.3 x 30.6 cm
(9⅛ x 12 in.)
National Museum
of China, Beijing

**The most evocative image
of the Modern Woodcut
Movement, the man tied
to the post represents
the plight of the Chinese
nation. It subsequently
became a symbol of
resistance during the
Sino-Japanese War.**

The Modern Woodcut Movement emerged in Shanghai in the late 1920s, when the poet and educator Lu Xun called for a new art that would give voice to the people of China and propagate social change. Lu Xun was a progressive, associated with the New Culture Movement through his membership of a group of influential modern writers, known as the May Fourth Movement, who rejected the country's classical culture in favour of one that embraced science and democracy and looked towards the radical European avant-garde for inspiration. Recognizing that the quickest way to disseminate art was through printing, the influential leftist writer became a passionate advocate of the woodcut print, forming the Morning Flower Society to promote European modern literature and art. The society staged exhibitions of prints by Käthe Kollwitz, Aubrey Beardsley and the Russian Constructivists and organized workshops. The resulting images were raw, bold, gestural and highly effective at conveying emotion.

By 1931, woodcut societies had been established in Shanghai, Hangzhou and Beijing, and revolutionary young artists were using the medium to criticize the ruling Nationalist Government and

promote a better, utopian future. As a result, many artists of the Modern Woodcut Movement were imprisoned and executed during the 1930s, including three of the founding members of the Morning Flower Society and one of the only female members, Xia Peng. After Lu Xun's death in 1936 and the Japanese invasion, the Modern Woodcut Movement became more patriotic and ideological and turned away from the early avant-gardist ideas. By 1949 any shoots of artistic experimentation had withered beneath the storm-blasts of Maoist ideology, and the last remnants of originality were later obliterated by the onset of the Cultural Revolution in 1966.

Hu Yichuan
To the Front, 1932
Woodcut, 23.3 x 30.6 cm
(9⅛ x 12 in.)
Lu Xun Museum,
Shanghai

Hu Yichun's formidable images had the power to inspire the Chinese people. This one is a call to arms; Yichun was arrested soon after its dissemination.

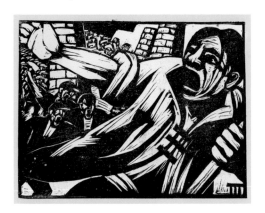

KEY ARTISTS
Chen Tiegeng (1908–69), China
Hu Baitao (1913–39), China
Hu Yichuan (1910–2000), China
Huang Shanding (1910–96), China
Jiang Feng (1910–83), China
Li Hua (1907–94), China
Xia Peng (1911–35), China

KEY FEATURES
Monochrome • Exaggerated imagery • Emotional • Political • Utopian • Experimental • Socially conscious • Satirical • Cynical • A sense of anger and disgust

MEDIA
Printing

KEY COLLECTIONS
National Art Museum of China, Beijing, China

ANTHROPOPHAGIA
1928–60s

In 1928 the poet Oswald de Andrade sought to scandalize Brazilian society out of its cultural lethargy with a provocative ideology called anthropophagy (literally meaning 'cannibalism'). Writing in the first issue of *Revista de Anthropofagia*, he argued that Brazil's greatest strength in the past had been in the devouring of its colonial oppressors to achieve autonomy. Now, he declared, it was Brazil's cultural duty to do the same with European culture, in order to create a uniquely Brazilian modernism. The editorial included a quotation by the sixteenth-century German explorer Hans Staden, who was captured by a Brazilian tribe: 'There you are, our food is jumping.'

It was de Andrade's wife, the artist Tarsila do Amaral, who first conceived of the idea of Anthropophagia. Her 1928 painting *Abaporu* depicted a monstrously distorted figure with a giant foot next to a cactus. The title was taken from a dictionary of the Tupi-Guarani language. *Aba* means 'man' and *poru* 'who eats'. The Tupi peoples were indigenous to Brazil in the precolonial era and had been thought to practice cannibalism. A similar image was used to illustrate her husband's manifesto, and later provided the basis for her most famous painting *Anthropophagy*.

The movement that emerged from de Andrade's provocative statement was typified by an aesthetic style that combined a kind of industrial primitivism – flat cityscapes and buildings – with bold

Emiliano di Cavalcanti
Five Girls from Guaratinguetá, 1930
Oil on canvas,
90.5 x 70 cm
(35⅝ x 27¼ in.)
Museu de Arte São Paulo
Assis Chateaubriand,
São Paulo

Di Cavalcanti was the patriarch of modern Brazilian painting. This image celebrates the rich bohemian street life of his native Rio de Janeiro.

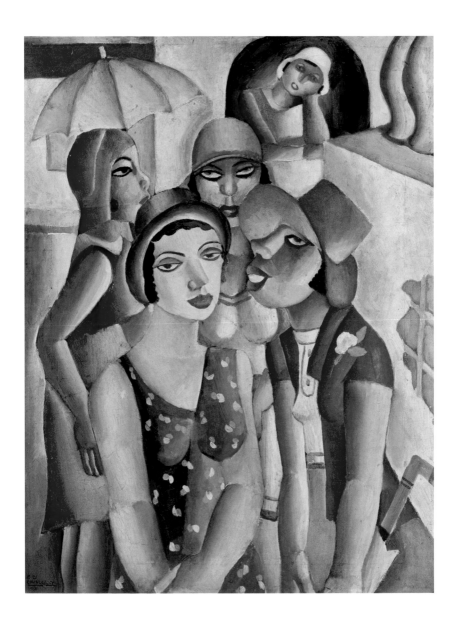

colour and strange anthropomorphic features that suggested
a form of Surrealism. Some of the artists and writers associated
with Anthropophagia were members of the radical avant-garde
Grupo dos Cinco, who had organized the ground-breaking Semana
de Arte Moderna (Week of Modern Art) in São Paulo in 1922,
which, amid the heckling from reactionary audiences, had brought
into focus a cultural explosion in the arts. Many of the artists had
studied in Europe and were aware of the modernist trends emerging
on the continent. Anthropophagia continued to influence Brazilian
culture, particularly with the rise of the Tropicália artists in the
1950s and 1960s.

Tarsila do Amaral
A Cuca (To Cuca), 1924
Oil on canvas,
60.5 x 72.5 cm
(23⅞ x 28¼ in.)
Musée de Grenoble,
Grenoble

**Do Amaral explored
the poetic potential of
her homeland through
imaginative imagery
that combined her
training in Paris with
Fernand Léger and
her contact with
the Surrealists.**

KEY ARTISTS

Tarsila do Amaral (1886–1973), Brazil
Victor Brecheret (1894–1955), Italy
Emiliano di Cavalcanti (1897–1976), Brazil
Anita Malfatti (1889–1964), Brazil
Lasar Segall (1891–1957), Lithuania

KEY FEATURES

Bold colour • Flatness • Strange juxtapositions • Whimsy and
dream imagery • Multiple perspectives • Exaggerated forms
• Precolonial influences

MEDIA

Oil paint • Sculpture

KEY COLLECTIONS

Fundação José e Paulina Nemirovsky, São Paulo, Brazil
Museu de Arte de São Paulo Assis Chateaubriand,
 São Paulo, Brazil

NÉGRITUDE
1935–60s

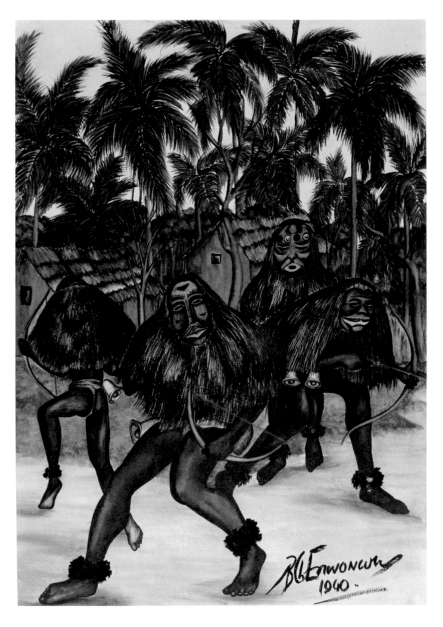

Ben Enwonwu
Ugala Masquerade, 1940
Watercolour on paper,
37.8 x 27.4 cm
(14⅞ x 10¾ in.)
Private collection

Enwonwu was instrumental in forging a new visual and cultural language in Nigeria. By incorporating Igbo symbolism and folk traditions he challenged the supremacy of western art.

The influential Négritude Movement began in Paris in the interwar years, when the Martinique-born Surrealist poet Aimé Césaire, together with his childhood friend the French poet Léon-Gontran Damas and the Senegalese poet Léopold Sédar Senghor, started the student journal *L'Étudiant noir* (The Black Student). The first issue was published in March 1935, featuring an essay by Césaire called '*Négreries*: Black Youth and Assimilation' – a robust and caustic response to western readings of black culture and literature. Césaire later explained that the term was broadly defined as 'the simple recognition of the fact of being black, and the acceptance of this fact, of our destiny as black people, of our history, and of our culture'.

The aim of the magazine was to bring students from the Africa diaspora together, to a place where race relations could be addressed. In the Paris avant-garde of the 1930s, during a period when black culture was highly fashionable, *L'Étudant Noir* was at the centre of a neocolonial movement for change that also included the sisters Jane and Paulette Nardal – who published the periodical *Revue du Monde Noir*, promoting the black writers of the Harlem Renaissance. The journal was supported by the Surrealist leader André Breton and the poets Robert Desnos and Michel Leiris.

During the years surrounding the Second World War, many of these artists and writers left Paris, developing other forms of Négritude in Africa and the Caribbean. These cultural pioneers used a wide variety of styles and sources to critique imperialism; the sculptor Ronald Moody explored Négritude themes in *Johanaan* (1936). The Nigerian painter Ben Enwonwu, who had studied at the Slade in London, used his art to challenge racial stereotypes and promote a form of Négritude in Nigera. Wifredo Lam articulated the physical and cultural displacement endured by African diasporic people in paintings such as *The Jungle* (*La Jungla*; 1943), by attempting to relocate black culture back in its own landscape. New forms of Négritude emerged across the African diaspora – as Creolization in the Caribbean, as the Natural Synthesis Movement in Nigeria and École de Dakar in Senegal as well as the expansive pan-African cultural movement.

On returning to the island of Martinique, Césaire and his wife, the poet Suzanne, founded the periodical *Tropiques* in 1941. Its revolutionary rhetoric and expeditions into the marvellous kept the voice of Surrealism alive when many European Surrealist groups had been silenced by Nazi invasion. The journal also inspired later black anti-colonial French-speaking writers, including Frantz Fanon and the poet and theorist Édouard Glissant.

After Léon Damas's collection of poems, *Pigments* (1937), was banned by the French government in 1939, the poet devoted his life to addressing the impact of colonization and racism. He continued to promote Négritude as an expansive ideology that could incorporate all of the African diaspora, writing 'Négritude has many fathers but only one mother'.

Senghor returned to Dakar, where he became president of Senegal in 1960 and established a lively form of Négritude in the country. His writings inspired many later revolutionists, most notably the liberation leader Amílcar Cabral who wrote of Césaire and Senghor in *Unity and Struggle* (1979): 'marvellous poetry written by blacks from all parts of the French world, poetry that speaks of Africa, slaves, men, life and human hopes.'

KEY ARTISTS
Agustín Cárdenas (1927–2001), Cuba
Ben Enwonwu (1917–94), Nigeria
Wifredo Lam (1902–82), Cuba
Ronald Moody (1900–84), Jamaica

KEY FEATURES
Images of black culture • History and everyday life • Multiple perspectives • African artistic traditions • Promoting race awareness and pride • Search for a modern black identity • Bold colour

MEDIA
Visual art • Literature • Poetry

KEY COLLECTIONS
Centre Pompidou, Musée National d'Art Moderne, Paris, France
Museum of Modern Art (MoMA), New York, NY, USA
Nigerian National Museum, Lagos, Nigeria
Tate, London, UK

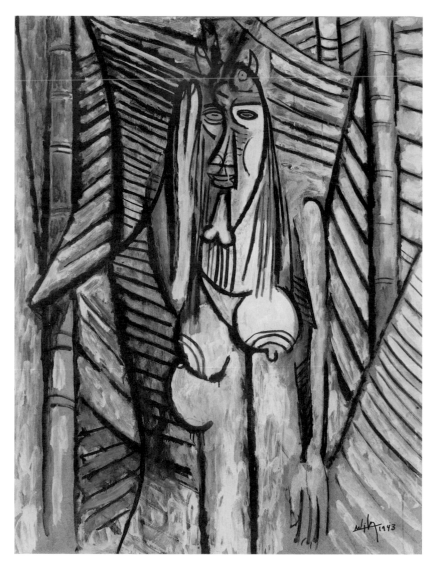

Wifredo Lam
The Murmur, 1943
Oil paint on paper
mounted on canvas,
105 x 84 cm
(41⅜ x 33⅛ in.)
Centre Pompidou, Paris

Lam's paintings were
highly complex,
incorporating religious
symbolism such as
Vodou, the rich colours
of Cuba's landscape
and critical social
commentary. The figure
in this painting could
represent a goddess or a
prostitute.

EGYPTIAN SURREALISM
1937–45

In 1937 a group of young, cosmopolitan artists and writers from Cairo turned their vitriol on the Egyptian establishment, denouncing the use of art for political propaganda. In their 1938 manifesto *Long Live Degenerate Art*, they rejected Arab nationalism and voiced solidarity with the avant-garde artists and writers being persecuted in Nazi Germany.

The group signed themselves Arte et Liberté (jama'at al-fann wa al-hurriyyah; Art and Liberty), and through their art and their poetry, sought to highlight the extreme inequalities of Egyptian society. They stood against order, logic and beauty, and initially drew on the European model of Surrealism, introduced to them through the writer André Breton and the photographer Lee Miller, before forging their own distinctive character. They were politically motivated, supporting collective action, and highlighted social issues and were concerned with civil rights and free speech. They thought of themselves as independent radicals and believed in the complete freedom of art. Their paintings were violent depictions of deformed and dismembered bodies created to partly expose the rot in Egyptian society and later in horror at the Second World War.

One of the distinctive aspects of the group was the close collaboration between artists and poets, with many of the artists illustrating Surrealist texts. The poet provocateur Georges Henein published journals in Arabic and French, and the painter Ramses Younane conceived of a new form of Surrealism free of Freudian constraints, called *Subjective Realism*, in which artists were

Ramses Younane
Untitled, 1939
Oil on canvas, 46.5 x
35.5 cm (18¼ x 14 in.)
Al Thani Collection, Doha

The restlessly inventive Younane is today considered to be Egypt's foremost Surrealist painter. This provocative image of a deformed and mutilated body is a metaphor for the social corruption the artist saw in Egyptian society and the horrors of war.

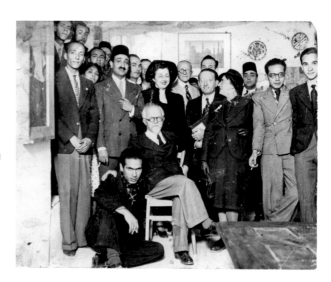

Members and associates of Arte et Liberté
c.1945
Photograph

The radical collective of artists and writers based in Cairo was photographed in La Maison des Artistes, Darb El-Labana Citadel, Cairo. The group included several prominent female artists such as Inji Efflatoun and Amy Nimr.

encouraged to adopt any formal style and subject matter they liked. The group continued to participate in International Surrealism until the mid-1940s when, disillusioned by the movement's support of Stalin, they broke away.

Yet their progressive ideology influenced many painters and poets, including the British artist and critic Victor Musgrave, the London-based photographer Ida Kar and the militant Surrealist Egyptian–French poet Joyce Mansour.

Amy Nimr
Underwater (Underwater Skeleton), 1943
Gouache on wood,
54 x 45.5 cm
(21¼ x 17⅞ in.)
HE Sheik Hassan MA,
Al Thani Collection, Doha

Nimr had studied at the Slade in London where she had encountered the Bloomsbury set and the Paris Surrealists, bringing her avant-gardist ideas back to Egypt when she returned in the early 1930s.

KEY ARTISTS
Inji Efflatoun (1824–89), Egypt
Ida Kar (1908–74), Russia
Mayo (Antoine Malliarakis Mayo) (1905–90), Greece–France
Amy Nimr (1907–74), Egypt
Kamel El-Telmissany (1915–72), Egypt
Hassan El-Telmissany (1923–87), Egypt
Ramses Younane (1913–66), Egypt

KEY FEATURES
Strange juxtapositions, whimsy and dream imagery • Ambiguity • Writing with pictures • Deformed and distended bodies • Themes of fear and desire

MEDIA
Oil paint • Photography

KEY COLLECTIONS
Al Thani Collection, Doha, Qatar
European Cultural Centre of Delphi, Athens, Greece
Museum of Modern Egyptian Art, Cairo, Egypt

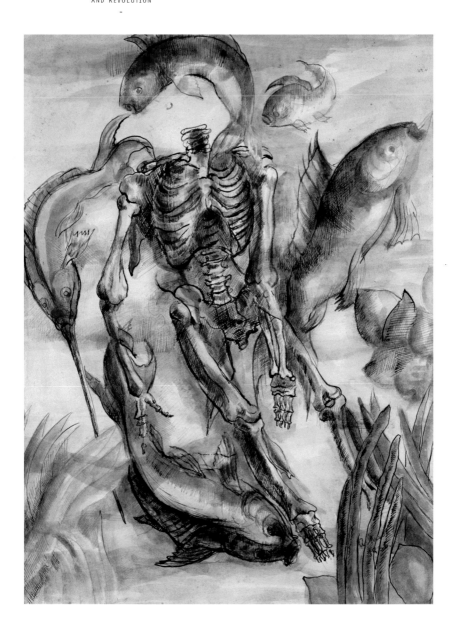

CALCUTTA GROUP
1943–53

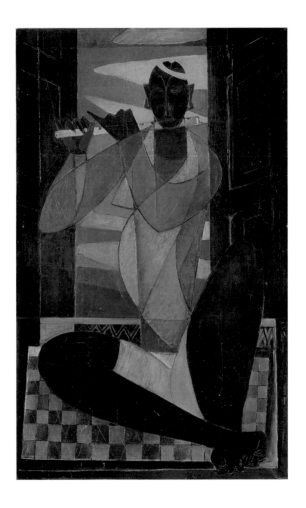

In 1943 eight ambitious young artists met in Calcutta (now Kolkata) to discuss a crisis in Indian painting. The artists had all trained in Bengal (see pages 10–13). Although this was the region where the Bengal Renaissance was kick-started in the late 1800s, by the early 1940s they had become disillusioned by the Bengal School's inability to recognize the advances in modern art.

As committed revolutionaries they also believed that India's art needed to reflect the state of the nation. The horrific famine in

Paritosh Sen
Untitled, 1951
Oil on canvas,
111.1 x 75.2 cm
(43¾ x 29⅝ in.)
Private collection

Sen absorbed a multitude of influences, from European Cubism to the way colour was used in Indian miniatures and the fluid strokes of calligraphy in nineteenth-century Kālīghāt painting.

Bengal in 1943, caused partly by British Prime Minister Winston Churchill's orders to destroy the region's fishing fleet and stockpile food for the British army, had radicalized these young artists, with the sculptor Prodosh Dasgupta writing: 'The time to pre-occupy oneself with gods and goddesses was over. The artist could no longer be blind to his age and surroundings, his people and society.'

The Calcutta Group's early works were Social Realist in theme, depicting the starving masses and poverty of the region, yet they were wary of political propaganda, and soon began to incorporate influences from Europe, taking inspiration from Pablo Picasso, Henri Matisse and Constantin Brâncuși. The result was a synthesis between east and west. The group continued to promote their ideas over the next decade, with Dasgupta mentoring other young artists, in particular Francis Newton Souza and K. H. Ara who went on to found the Bombay-based Progressive Artists' Group in 1947 (see page 52–5). The group disbanded in 1953 soon after printing a handbook that outlined their manifesto and held their guiding motto: 'Art should aim to be international and interdependent. In other words our art cannot progress or develop if we always look back to our past glories and cling to our traditions at all costs.'

KEY ARTISTS
Prodosh Dasgupta (1912–91), Bangladesh
Gopal Ghose (1913–80), India
Rathin Maitra (1913–97), Bangladesh
Nirode Mazumdar (1916–82), India
Prankrishna Pal (1915–88), Bangladesh
Paritosh Sen (1918–2008), Bangladesh
Subho Tagore (1912–85), India

KEY FEATURES
Figurative and narrative • Multiple perspectives • Bold colour • Social comment • Images of the poor and oppressed • Indian subject matter

MEDIA
Painting • Sculpture

KEY COLLECTIONS
National Gallery of Modern Art, Mumbai, India
National Gallery of Modern Art, New Delhi, India
Victoria Memorial Hall, Kolkata, India

CONCRETE INVENTION
AND MADÍ ART
1944–50

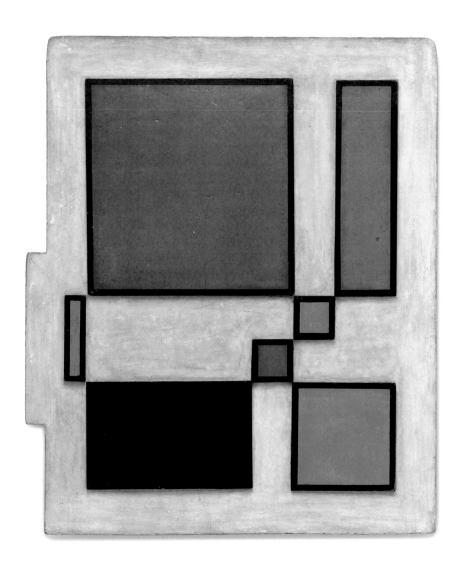

Rhod Rothfuss
Yellow Quadrangle, 1955
Alkyd and gouache on
board, 37 x 33 cm
(14½ x 13 in.)
Museum of Modern Art
(MoMA), New York

**Rothfuss made irregularly
shaped canvases in order
to remind the viewer
that they were looking
at a physical object,
not a 'window' into an
illusory world.**

In the 1930s a distinctive and confident non-representational
art swept through South America. It was known as Geometrical
Abstraction, or Concrete Art, and its diagonal lines, colour planes
and bold geometric shapes came to be seen as representative of the
rapid modernization happening in Latin America. The style gained
popularity in Venezuela, Brazil, Argentina and Uruguay, dominating
the artistic output of these countries.

For a group of young cosmopolitan artists in Buenos Aires,
Concrete Art had universal appeal. It was mathematical, mechanical
and non-figurative, and therefore – believed the artists – classless,
making it the ideal aesthetic with which to challenge the hierarchical
nature of Argentinian society.

Gyula Košice, Raúl Lozza and Tomás Maldonado considered
abstract art to be an art of the people, and outlined their aesthetic
expression of a new utopian society in their left-leaning journal
Arturo in 1944. Much of their original inspiration had come from
the single-issue French magazine *Art Concret* in which the principles
of geometric art had been outlined. Yet there were differences;
key to the Argentinian artists' thinking was the need for 'an urgent
response to a primarily political problem' – that of the 1943 *coup
d'état* led by General Arturo Rawson, which paved the way for
the populist leader Juan Domingo Péron being able to take power
in 1946. For the next decade, the country's intelligentsia would
be confronted by an isolationist, censorious dictatorship with
increasingly pro-fascist sympathies.

Two experimental abstract art groups emerged out of *Arturo*:
the Marxist, rationalistic Concrete-Invention Art Association
(Asociación Arte Concreto-Invención) led by Maldonado and the
Dada-inspired Madí Movement lead by Košice.

On the one hand, the paintings of the Concrete-Invention Art
Association were highly abstract, colourful and followed a strict
geometric structure reflecting the artists' desire for order and
equality. They described their artworks as 'inventions' and promoted
collective creativity over that of the individual. Many of the works
were unsigned or simply exhibited under the group's name.

Madí Art (Arte Madí), on the other hand, was irreverent
and humanist. The term Madí is thought to be an acronym for
Movimiento, Abstracción, Dimensión, Invención (Movement,
Abstraction, Dimension, Invention). They considered abstraction
to be expressive and romantic and argued that Concrete Art
was too inflexible and analytical to cope with the inconsistencies
of the modern world. Madí was to be continuously inventive
and experimental. They worked with water and light, making

hydrokinetic sculptures and using modern industrial materials such as Plexiglass. They published the journal *Arte Madí Universal*, in which they outlined their energetic vision for an art that was both classless and boundless in space and time. 'MADÍ destroys the TABOO OF PAINTING by breaking with the traditional frame,' wrote Košice in the group's manifesto of 1947, and the artists achieved this by painting on irregularly shaped canvases.

Both movements were relatively short-lived yet together they set a precedent for art in Argentina that remained committed to non-representational and experimental art for the next thirty years.

Carmelo Arden Quin
Carres, 1951
Lacquer on wood,
87 x 90 cm
(34¼ x 35⅜ in.)
Tate, London

Carmelo Arden Quin's artworks blurred the distinctions between sculpture and painting. The brightly coloured geometrical shapes were free of symbolic meaning, focusing on form rather than content.

KEY ARTISTS

Gyula Košice (1924–2016), Czechoslovakia–Argentina
Raúl Lozza (1911–2008), Argentina
Tomás Maldonado (1922–2018), Argentina
Lidy Prati (1921–2008), Argentina
Rhod Rothfuss (1920–69), Uruguay
Carmelo Arden Quin (1913–2010), Uruguay
Augusto Torres (1913–92), Uruguay

KEY FEATURES

Geometric abstraction • Bold diagonal lines • Colourful
• Irregularly shaped canvases • Playful • Attention
to detail • Clarity • Cool execution

MEDIA

Industrial materials • Plexiglass • Paint • Sculpture

KEY COLLECTIONS

Latin American Art Museum of Buenos Aires (MALBA),
 Buenos Aires, Argentina
Museo Košice, Buenos Aires, Argentina
Museum of Geometric and MADI Art, Dallas, TX, USA

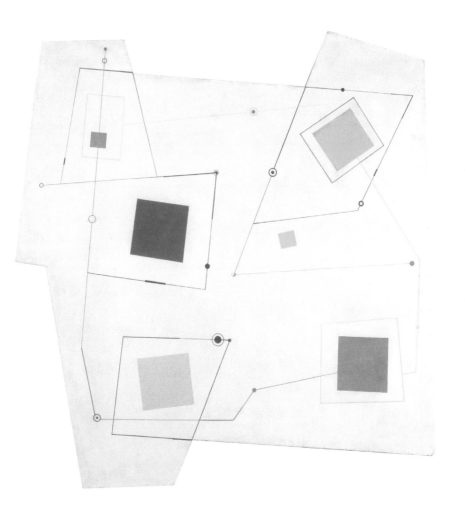

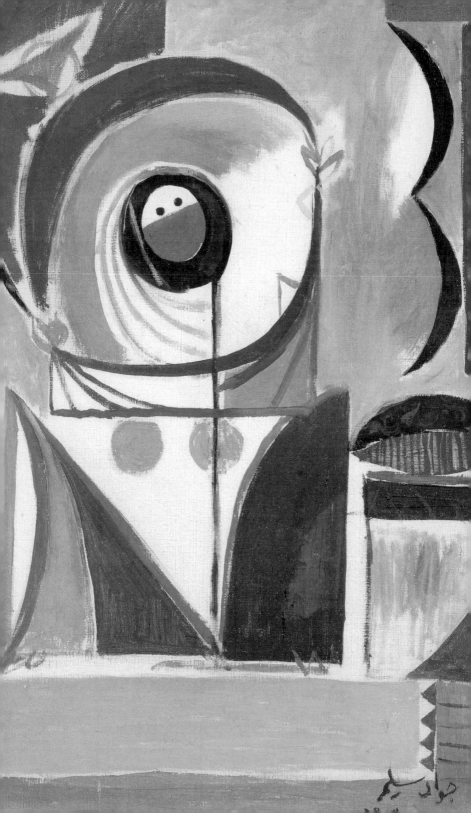

POST-WAR AND INDEPENDENCE

-

A work of art has value only if tremors
from the future run through it

-

André Breton, 1934

EUROPEAN SCHOOL
1945–57

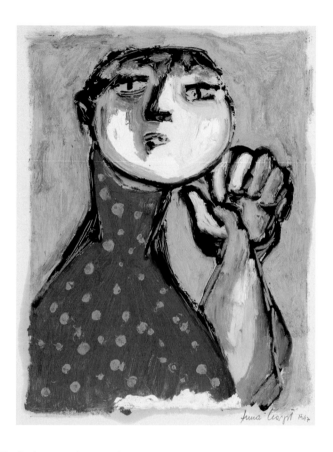

Formed in Budapest in the immediate post-war era, the European School (Európai Iskola) was a utopian movement of Hungarian artists, writers and theorists, who sought to unify a fractured Europe through a common art and culture. Out of the war-torn rubble, Dadaist brothers Imre Pán and Árpád Mezei called for a synthesis of east and west, arguing that 'Europe and the old Europe ideal have been destroyed'. They wanted an inclusive avant-garde art that would educate the public and ensure that the atrocities of the Second World War never happened again. To this end, they listed among the founding members two painters who had been killed in the Holocaust: Expressionist painter Imre Ámos and the Surrealist artist Lajos Vajda.

Margit Anna
*Woman in
Dotted Dress*, 1947
Oil on paper, 47 x 35 cm
(18½ x 13¾ in.)
Janus Pannonius
Múzeum, Pécs / Ferenczy
Múseum, Szentendre

**Margit Anna was
inspired by Marc
Chagall and developed
a lyrical Surrealism,
employing grotesque and
exaggerated details in
her paintings, such as the
arm in this picture.**

Over the next few years the European School published pamphlets, staged events and held exhibitions of abstract art in the working-class districts of Budapest. Inevitably, aesthetic and philosophical differences did surface as a factor, with the group becoming idealistically divided between Surrealism and Abstraction. After the communist takeover of Hungary in 1948, and the later introduction of a state-approved Soviet-style Socialist Realist art, it became harder for the artists of the European School to promote their activities.

The cultural theorist Ernő Kállai, who was a champion of abstract art, was attacked publicly for his bourgeois ideas. In 1956, a few months before the Hungarian Revolution, Pán and the painter Margit Anna (wife of Imre Ámos) read aloud a manifesto in the Café New York citing their opposition to the ruling order and their determination to change Hungarian culture. Both were silenced. Anna ceased painting until the mid-1960s, while Pán escaped to Paris and the European School disbanded soon after.

KEY ARTISTS
Margit Anna (1913–91), Hungary
Endre Bálint (1914–86), Hungary
Béla Bán (1909–72), Hungary–Israel
Jen Barcsay (1900–88), Hungary
Lajos Barta (1899–86), Hungary
Tihamér Gyarmathy (1915–2005), Hungary
Tamás Lossonczy (1904–2009), Hungary
Ödön Márffy (1878–1956), Hungary

KEY FEATURES
Whimsy and dreamlike imagery • Themes of fear and desire • Fields of colour • Geometric shapes • Non-representational

MEDIA
Poetry readings and performance • Painting • Sculpture • Collage

KEY COLLECTIONS
Hungarian National Gallery, Budapest, Hungary
Janus Pannonius Múzeum, Pécs, Hungary
The Hall of Art, Budapest, Hungary

Tamás Lossonczy
Chain Reaction, 1946
Oil on canvas,
95 x 150 cm
(37⅜ x 59 in.)
Private collection

Lossonczy was fascinated
by science; his poetic
compositions suggest
chemical compounds
and collections of cells.

PROGRESSIVE ARTISTS' GROUP
1947–51

The influential yet short-lived Progressive Artists' Group (PAG) was formed in Bombay (now Mumbai) in 1947 during the year of Indian Independence. Its principal founder and spokesperson was the artist and agitator Francis Newton Souza. He was a charismatic and rebellious individual, who had been expelled from school for making pornographic drawings and kicked out of the Sir J. J. School of Art at twenty-one for objecting to British academic teaching.

Souza experimented with Social Realism and Expressionism before coming into contact with the Calcutta Group's work (see page 40). Their outspoken desire for an all-Indian art inspired Souza

Maqbool Fida Husain
Untitled, 1956
Oil on canvas, 96.5 x 252.7 cm (38 x 99½ in.)
Private collection

A charismatic artist, Husain began his career painting billboards for feature films. When he was a member of PAG his art celebrated a newly liberated India, while also echoing the painful legacy of partition.

and his friend Sayed Haider Raza to form a movement that would combine avant-garde styles – Fauvist colours, Cubist forms and Expressionist brushwork – with Indian subject matter alive with mythologies and religious symbolism. That the group's formation concided with the independence of India was, according to Souza, vital but coincidental. Yet it was a fine time to be an artist forging a modern Indian art for a new country. The influx of Jewish refugees escaping war-torn Europe had brought artists and patrons from Austria and Germany to Bombay, keen to participate in the nascent exuberance of the post-Partition years and support young artists.

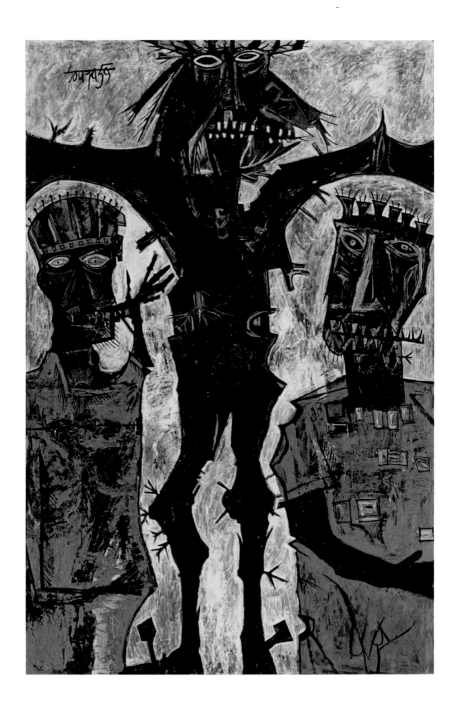

Francis Newton Souza
Crucifixion, 1959
Oil paint on board,
183.1 x 122 cm
(72⅛ x 48 in.)
Tate, London

**In this dynamic and
brutally humanistic
portrait, Souza refutes
the idea of a blond,
benign Christ and
paints him as black
with matted hair and
bloodied by thorns.**

The group met frequently at the Chetana Restaurant, favoured by the metaphysical writer Raja Rao and the nationalist poet and novelist Mulk Raj Anand, who published the art magazine *Marg* (Modern Architectural Research Group). The restaurant provided a space for the artists to exhibit their work away from the more conventional artistic salons. PAG's last exhibition was with the Calcutta Group in 1951, by which time Souza had already moved to London, Raza to Paris. Another key member of the group, Maqbool Fida Husain, was driven into exile in the 1990s by repeated death threats from Hindu fundamentalists.

KEY ARTISTS
Krishnaji Howlaji Ara (1912–85), India
Sadanand Bakre (1920–2007), India
Hari Ambadas Gade (1917–2001), India
Vasudeo S. Gaitonde (1924–2001), India
Maqbool Fida Husain (1915–2011), India
Krishen Khanna (b.1925), India
Sayed Haider Raza (1922–2016), India
Francis Newton Souza (1924–2002), India

KEY FEATURES
Depictions of everyday life • Mysticism • Landscapes in an Expressionist style • Bold colours • Multiple perspectives • Expressive brushwork

MEDIA
Painting

KEY COLLECTIONS
National Gallery of Modern Art, New Delhi, India
Victoria and Albert Museum (V&A), London, UK
Tate, London, UK

HUROUFIYAH
1949–70s

Huroufiyah (*harf/huruf* meaning 'letter' in Arabic) is the term used
to describe the use of the Arabic letter in modern art. While Arabic
script has been used in Islamic art for centuries, it was in the mid-
twentieth century that artists from North Africa and the Middle
East began to experiment with Arabic letters, incorporating them
into their abstract paintings.

Jewad Selim
*Woman Selling
Material*, 1953
Oil on board, 53.5 x
43.5 cm (21⅛ x 17⅛ in.)
Barjeel Art Foundation,
Sharjah

**Iraqi artist Selim
was a founder member
of the Baghdad Modern
Art Group. His playful,
geometric paintings
incorporated calligraphic
motifs and Cubist
elements. He was a
powerful artistic force
in the country, but died
prematurely at the age
of forty-two.**

One of Huroufiyah's earliest promoters was the Iraqi-Syrian artist Madiha Omar. She wrote about the dynamism of Arabic calligraphy as a form of abstract design in a catalogue essay for her first exhibition in Georgetown Public Library in Washington, DC, in 1949. A few years later, the one-time Surrealist painter Jamil Hamoudi began using the Arabic letter in his experimental Cubist paintings. In Sudan in the 1960s, the painter Ibrahim El-Salahi, as part of the loosely based Khartoum School, also began incorporating the script into his works (see pages 60–61) .

Huroufiyah emerged around the same time that the mainly secular, transnational and political movement pan-Arabism was gaining popularity. It was devoted to the idea of the unification and modernization of the Arab-speaking world, and for some artists, Huroufiyah came to symbolize pan-Arabism's unifying ideals.

In the 1960s Omar and Hamoudi joined the group One Dimension with Iraqi painter Shakir Hassan al-Said, with the desire to create a unifying modern art through the expressive use of calligraphy. For these artists, Huroufiyah was an almost existential concept, a way of conveying the 'essence of being' through Arabic letters. Other promoters of Huroufiyah were Dia al-Azzawi and his New Vision Group, founded in Baghdad in the late 1960s (see pages 120–21).

KEY ARTISTS
Dia al-Azzawi (b.1939), Iraq
Jamil Hamoudi (1924–2005), Iraq
Madiha Omar (1908–2005), Iraq
Shakir Hassan al-Said (1925–2004), Iraq
Ibrahim El-Salahi (b.1930), Sudan
Jewad Selim (1919–61), Iraq

Overleaf: Madiha Omar
Untitled, 1978
Watercolour on
paper, 31 x 44 cm
(12¼ x 17⅜ in.)
Barjeel Art Foundation,
Sharjah

**Several of Omar's
paintings were housed in
Iraq's National Museum
of Modern Art and were
damaged or destroyed
during the Iraq War
(2003–11). This vibrant
abstract is one of her few
remaining works.**

KEY FEATURES
Incorporation of Arabic letters • Patterned and highly decorative • Abstraction • Expressive brushwork • Flat surfaces

MEDIA
Oil paint • Watercolour • Traditional materials

KEY COLLECTIONS
Barjeel Art Foundation, Sharjah, United Arab Emirates
Jordan National Gallery of Fine Arts, Amman, Jordan
Mathaf: Arab Museum of Modern Art, Doha, Qatar

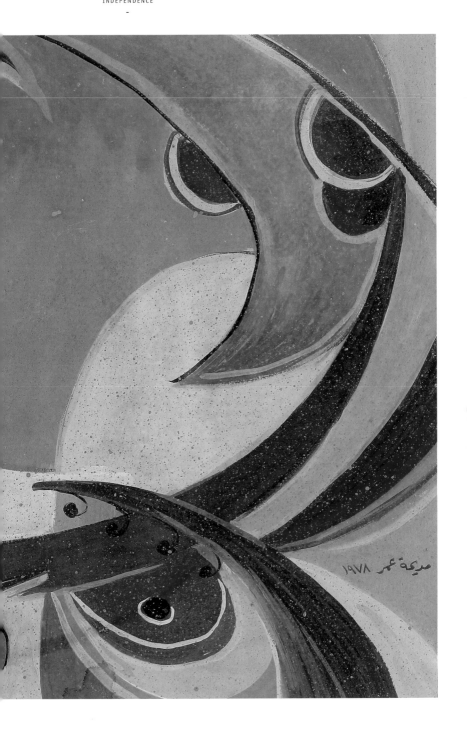

KHARTOUM SCHOOL
c.1950s–70s

The Khartoum School is the name for an informal group of artists who were associated with a wider intellectual movement in Sudan aiming to develop a new cultural identity in the late colonial and postcolonial era. The vanguard was led by Osman Waqialla, who, as a lecturer at the College of Fine and Applied Art in Khartoum, promoted a new visual vocabulary rooted in Arabic calligraphy.

 The challenge for the artists of the Khartoum School, many of whom had studied in London, was the culturally diverse and multifaceted nature of Sudan, one that was loosely polarized between the Islamic, Arabized north and the African cultural traditions of the south. Waqialla was closely associated with the Sudanese literary movement the School of the Jungle and Desert, and the artist believed that the country's rich verbal history could be reflected in paintings that used Arabic calligraphy.

Ibrahim El-Salahi
*Reborn Sounds of
Childhood Dreams 1*,
1961–5
Enamel paint and
oil paint on cotton,
258.8 x 260 cm
(101⅞ x 102⅜ in.)
Tate, London

**Painted on *damouriya*,
a hand-woven textile,
the ghostly figures recall
African masks and the
veils worn by Sudanese
women. El-Salahi was
Sudan's leading artist and
established the country's
first Department of
Culture, before being
imprisoned for anti-
government activities.
This brutal experience
informed much of his
later work.**

Waqialla's pupils took this idea further, working to develop an entirely new visual vocabulary that would express their dual Arabic and African identity. On returning from the Slade School of Art in London, Waqialla's one-time student Ibrahim El-Salahi began to develop a semi-abstract style that incorporated Arabic letters, African masks and motifs and the colours of the country's landscape. This idea was further explored by artists using traditional printmaking techniques and colours made from natural dyes.

The Khartoum School's aesthetic continued to be widely promoted in Sudan until the early 1970s, when younger artists began to challenge its dominance. The artist Kamala Ibrahim Ishaq went on to form the Crystalist Group, which sought to create a new language in art that was as multifaceted as a crystal cube: translucent, interconnected and constantly changing according to the viewer's perspective. This vibrant period of cultural debate was cut short by a crackdown on left-wing radicals in the late 1970s and many artists left the country.

KEY ARTISTS
Kamala Ibrahim Ishaq (b.1939), Sudan
Magdoub Rabbah (b.1933), Sudan
Ibrahim El-Salahi (b.1930), Sudan
Ahmed Shibrain (b.1931), Sudan
Osman Waqialla (1925–2007), Sudan

KEY FEATURES
An integration of Islamic, African, Arab and Western artistic traditions • Influenced by African masks • Arabic calligraphy • Stitched-cloth canvases • Dreamlike imagery • Earthy colours reflecting the Sudanese landscape

MEDIA
Painting • Sculpture • Printmaking • Traditional textiles • Natural dyes

KEY COLLECTIONS
Barjeel Art Foundation, Sharjah, United Arab Emirates
National Museum of Sudan, Khartoum, Sudan
Sharjah Art Foundation, Sharjah, United Arab Emirates
Tate, London, UK

REPORTAGE PAINTING
1950s

In 1949 the Japanese literary critic Kiyoteru Hanada and the Surrealist artist and writer Okamoto Tarō formed the Avant-Garde Study Group to support emerging Japanese artists in the wake of the Second World War. Hanada was a Marxist theorist and the group promoted a left-wing agenda at odds with the prevailing government and the occupying US military forces. Okamoto, who had spent his pre-war years in Paris collaborating with the erotic mystic writer Georges Bataille and Surrealist leader André Breton, was committed to the rehabilitation of Japanese society in the wake of the atomic bombs dropped on Hiroshima and Nagasaki. The group believed art must confront the polarities inherent in post-war Japanese society – one that was trying to rebuild its shattered self-esteem after atomic annihilation while being controlled by the occupying US forces who had a conflicting agenda. It was a critical time, with many theorists and artists debating which direction modern Japanese art should take, and many supporting a form of Japanese Social Realism.

Out of this society emerged young, subversive, socially aware artists who began to depict the political realities of Japan in a Surrealist non-naturalistic way – distorted figures, monsters and semi-abstract motifs. These pictures, together with more Social Realist depictions of Japanese life, were loosely collected under the heading 'Reportage' painting, although the styles and aesthetics differed considerably. They ranged from Ikeda Tatsuo's 1954 artwork *10,000 Count* depicting irradiated fish – part of a series of paintings he made about the fallout from the US military hydrogen bomb testing on Bikini Atoll – to Madokoro (Akutagawa) Saori's distorted female figures inspired by Japanese mythology. Operating concurrently to these painters was a realist photography movement led by the highly influential photographer Ken Domon who sought to capture the realities of post-war Japanese life. The Reportage aesthetic continued until the late 1950s, when the influx of western avant-garde ideas dramatically transformed the visual environment of Japan.

Opposite: Ikeda Tatsuo
10,000 Count, 1954
Pen, ink and conté
crayon on paper,
27.8 x 37.3 cm
(11 x 14⅝ in.)
Museum of
Contemporary Art, Tokyo

This painting comes from a series of works made in response to the US military presence in Japan. The grotesque, almost-human features of the fish, caught in the net of an irradiated fishing boat, expressed the artist's horror at nuclear testing.

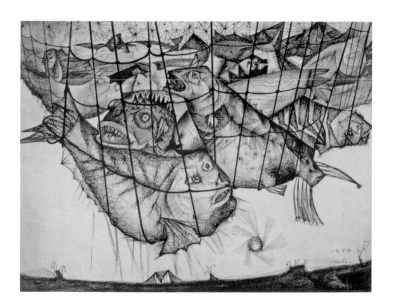

Overleaf: Okamoto Tarō
Law of the Jungle, 1950
Oil on canvas, 181.5 x
259.5 m (71¼ x 102⅛ in.)
Tarō Okamoto Museum
of Art, Kawasaki

Here, Okamoto Tarō
promotes 'polarism' –
a theory invented by
the artist in which both
abstract and Surrealist
ideas are used in a single
picture. Okamoto argued
that it was only by using
both that he could
confront the complex
social realities in
post-war Japan.

KEY ARTISTS

Ikeda Tatsuo (b.1928), Japan
Kawara On (1932–2014), Japan
Madokoro (Akutagawa) Saori (1924–66), Japan
Nakahara Yūsuke (1931–2011), Japan
Nakamura Hiroshi (b.1932), Japan
Okamoto Tarō (1911–96), Japan
Yamashita Kikuji (1919–86), Japan

KEY FEATURES

Grotesquely distorted or fragmented figures • Dreamlike imagery
• Social comment • Images of the oppressed • Narrative
• Abstract forms

KEY MEDIA

Oil painting • Photography • Printing

KEY COLLECTIONS

Ken Domon Museum of Photography, Yamagata, Japan
MOT Collection, Museum of Contemporary Art, Tokyo, Japan
National Museum of Modern Art, Tokyo, Japan
Nerima Art Museum, Tokyo, Japan
Tarō Okamoto Memorial Museum, Tokyo, Japan

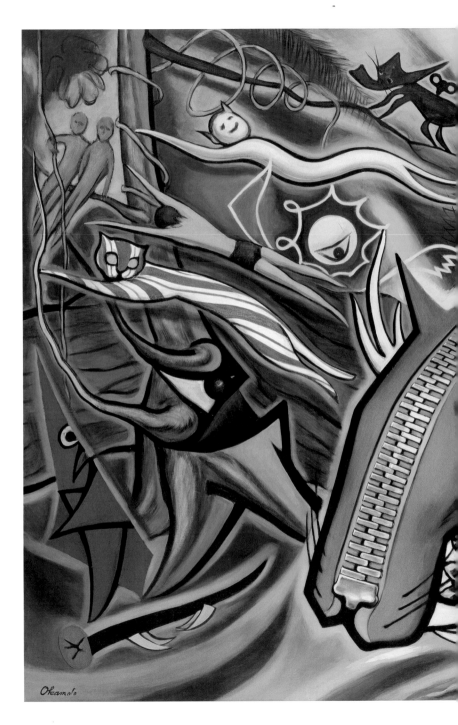

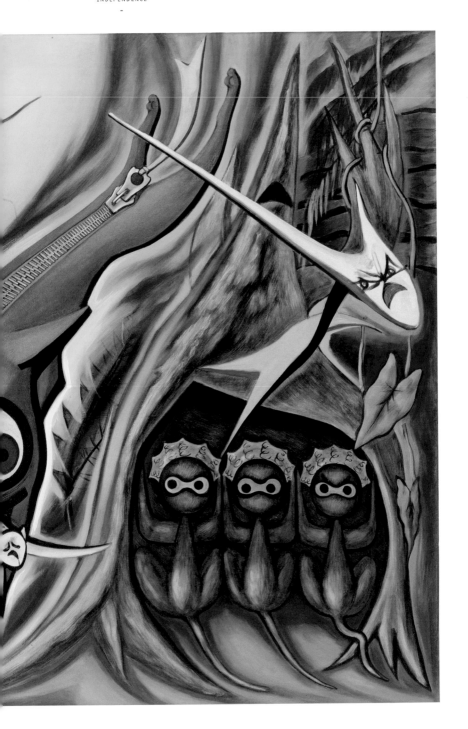

JIKKEN KŌBŌ
1951–7

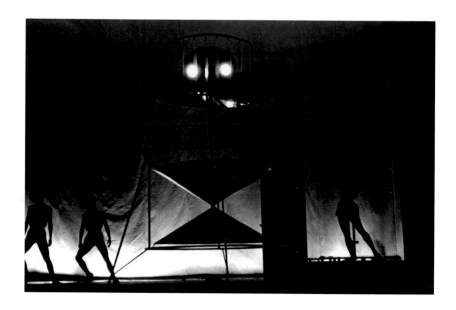

Jikken Kōbō (Experimental Workshop) began in Tokyo in 1951 with a diverse association of artists, composers and poets who met once a week to discuss avant-garde art. Out of these discussions, the members began to work collaboratively on projects – the first being a ballet to mark the opening of a Picasso exhibition in Tokyo in 1951.

They held concerts – introducing the work of European avant-garde composers to Japanese audiences – and staged exhibitions of the plastic arts. Before long they were experimenting with integrating these two media into larger theatrical exercises. It was not until they began using automatic slide projectors in the mid-1950s that they started synchronizing music, poetry and art together into great 'synthetic poems'.

As these experimental workshops continued, the performances became more abstract and dissonant. They incorporated documentary footage, atonal music, cut up words, speeded up recordings and layered sound almost like a Dadaist collage, which led

Jikken Kōbō
Tomorrow's Eve Ballet,
29–31 March, 1955
Photograph of
performance
Haiyūza Theatre,
Roppongi, Tokyo

The group were keen to introduce Japanese audiences to European avant-gardists. This ballet was based on the 1886 novel *Tomorrow's Eve* by the French Symbolist writer Auguste Villiers de l'Isle-Adam.

to the French critic Michel Tapié comparing their spirit of inquiry to that of Marcel Duchamp. The group's mentor, the Surrealist artist and poet Takiguchi Shūzō, encouraged the group to publish journals, which helped disseminate their ideas. Jikken Kōbō remained active for much of the 1950s and pioneered the future anti-art movement in Japan.

KEY ARTISTS

Fukushima Hideko (1927–97), Japan
Kitadai Shōzō (1921–2001), Japan
Komai Tetsurō (1920–76), Japan
Takiguchi Shūzō (1903–79), Japan
Yamaguchi Katsuhiro (1928–2018), Japan

KEY FEATURES

Layered images, text and sounds • Non-narrative structure • Collaboration between musicians, artists and writers • Experimental • Transgressive

KEY MEDIA

Performance • Film • Collage • Music • Slide projectors

KEY COLLECTIONS

Chiba City Museum of Art, Chiba, Japan
Museum of Contemporary Art, Tokyo, Japan
Museum of Modern Art, Kamakura & Hayama, Japan

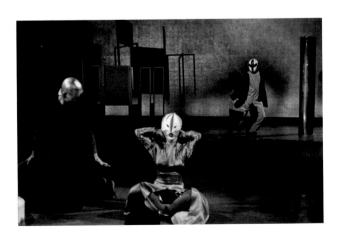

Jikken Kōbō
Arnold Schoenberg's
Pierrot Lunaire,
5 December 1955
Photograph of
performance by
the Circular Theatre
Sankei International
Conference Hall, Tokyo

**A photograph of
a performance by
Jikken Kōbō of Arnold
Schoenberg's 1912
melodrama *Pierrot
Lunaire* staged as
part of *An Evening of
Original Plays*.**

SAQQAKHANEH ARTISTS
1950s–60s

Saqqakhaneh (or Saqqakhana) refers to a loose association of artists who emerged in the late 1950s referencing Iranian popular culture, craft and religion in their works of art. Many of the artists had studied at Tehran's College of Decorative Arts during a period of cultural optimism in the early 1950s and were keen to develop a cosmopolitan, Shi'i Islamic visual culture that could be understood by all.

The term was first used by the Iranian art critic Karim Emami after seeing the mystical paintings of Charles-Hossein Zenderoudi at the Third Tehran Biennial in 1962. Zenderoudi took some of his inspiration from small religious objects and it prompted the critic to suggest Zenderoudi's art reminded him of the talismans found in *saqqakhanehs* (public fountains) used for prayer. Soon Saqqakhaneh became a catch-all for a diverse group of politically minded modern artists who were pushing the boundaries of traditional Iranian painting in multifarious ways, but were all united in the belief that by incorporating everyday imagery in their artworks they could challenge art's elitist nature.

Their semi-abstract imagery was inspired by political and religious texts, textiles, domestic items, geometric patterns and Pop culture, and they purposely used traditional materials, such as pen and ink, mosaic and those employed in printmaking. They were also influenced by western trends, including Pop Art and Land Art, while also looking to pre-Islamic Iran. The Saqqakhaneh artists continued to be a cultural force in Iran until the revolution in 1979.

Charles-Hossein Zenderoudi
Vav + Hwe, 1972
Acrylic on canvas,
200 x 200 cm
(78¾ x 78¾ in.)
Private collection

This is part of a larger series of square paintings the artist made in the early 1970s that use concentric rings of the Arabic alphabet to create the illusion of perspective and the atmosphere of limitless space.

KEY ARTISTS

Siah Armajani (b.1939), Iran

Monir Shahroudy Farmanfarmaian (1922–2019), Iran

Faramarz Pilaram (1937–82), Iran

Parviz Tanavoli (b.1937), Iran

Charles-Hossein Zenderoudi (b.1937), Iran

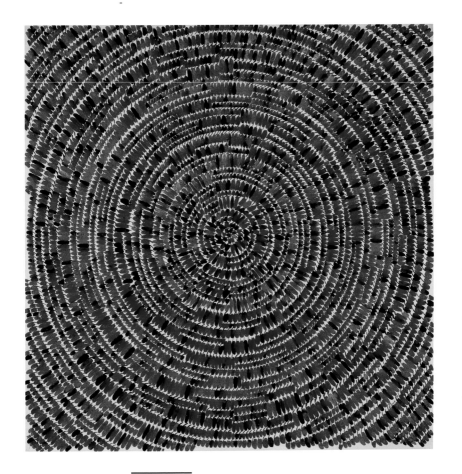

KEY FEATURES
Geometry • Arabic calligraphy • Intricate patterns • Bold,
graphic everyday imagery • Mirror mosaics

MEDIA
Mosaic • Painting • Sculpture • Textiles • Pen and ink on paper
• Printmaking

KEY COLLECTIONS
Monir Museum, Tehran, Iran
Tate, London, UK
Tehran Museum of Contemporary Art, Tehran, Iran

ZARIA REBELS
1958–60s

In 1961 a young Nigerian painter called Uche Okeke wrote in the Natural Synthesis manifesto that:

> Our new society calls for a synthesis of old and new, of functional art and art for its own sake . . . It is equally futile copying our old art heritages, for they stand for our old order. Culture lives by change. Today's social problems are different from yesterday's, and we shall be doing a grave disservice to Africa and mankind by living in our father's achievements.

What Okeke was articulating was a fundamental paradox faced by many artists in postcolonial societies: a desire to resurrect traditional forms of artistic expression while at the same time acknowledging the advances that had happened in western modern art.

Okeke was a member of the short-lived avant-garde Zaria Art Society, founded in 1958 at the Nigerian College of Arts, Science and Technology, in order to develop a strong cultural identity. They became known as the Zaria Rebels when they articulated their plan to create a modern Nigerian art informed by indigenous art practices. To this end, the rebels travelled across the country studying African legends, historical figures, myths and philosophies and experimenting with traditional art techniques such as *uli* – a traditional style of body and wall decoration.

In the optimistic atmosphere following Nigeria's independence in 1960, they applied themselves to the task of rediscovering artistic practices that had been suppressed during colonization. Okeke established the Mbari Enugu, where ex-rebels and members of the literary avant-garde came together to define this new cosmopolitan aesthetic. Although the group disbanded in 1961, they continued to work together and later formed the Society of Nigerian Artists in 1964, before the outbreak of civil war in 1967 turned their attention to humanistic representations of the conflict.

Uche Okeke
Ana Mmuo
(Land of the Dead), 1961
Oil on board,
92 x 121.9 cm
(36¼ x 48 in.)
National Museum
of African Art,
Washington, DC

**Okeke formulated
a distinctive style
associated with Igbo
folk tales, *uli* body
painting and mythical
creatures derived from
ancient Iron Age Nok
terracotta sculptures.**

KEY ARTISTS
Yusuf Grillo (b.1934), Nigeria
Demas Nwoko (b.1935), Nigeria
Uche Okeke (1933–2016), Nigeria
Bruce Onobrakpeya (b.1932), Nigeria

KEY FEATURES
Indigenous art traditions such as body art and wall
decoration • Cosmic and animal forms • Dreamlike
imagery • Traditional folklore

MEDIA
Printmaking • Painting • Sculpture • Pen and ink drawing

KEY COLLECTIONS
National Gallery of Art, Abuja, Nigeria
National Gallery of Modern Art, Lagos, Nigeria
National Museum of African Art, Washington, DC, USA

DAKAR SCHOOL
1960-74

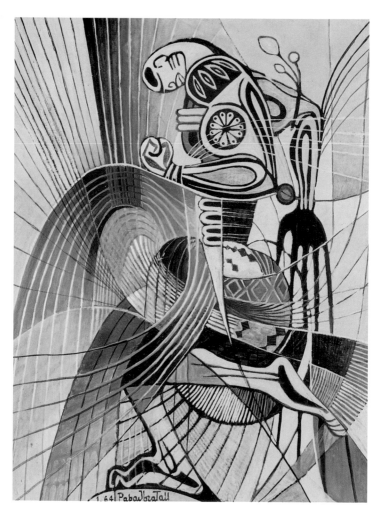

In 1960 the political activist, poet and Afro-Surrealist Léopold
Sédar Senghor became the first president of Senegal following
independence. As one of the founder members of the Négritude
Movement in Paris in the 1930s (pages 32–5), Senghor believed in
establishing unity through a socialist cultural identity. To this end,
he instigated radically vibrant arts policies, establishing a national
museum, art schools, cultural festivals and touring exhibitions

and promoting a distinctly modern African voice in the arts. His philosophy was a response to colonialism and anti-colonial agitation, and sought to reflect a universal black experience in order to forge solidarity across Africa and its diaspora. As Senghor wrote in 1956: 'a negro style of sculpture, a negro style of painting, even a negro brand of philosophy, have now made themselves keenly felt and have become part of humanity's shared heritage.'

He invited the painter Iba N'Diaye to set up the Plastic Arts Department at Dakar's École des Beaux-Arts, which was loosely based on the Paris school. It was here that artists N'Diaye, Papa Ibra Tall, Pierre Lods, Amadou Bâ, Amadou Dédé and Ibou Diouf, among others, began to develop a two-dimensional hybrid art incorporating African aesthetics, western avant-gardism, bold graphics and abstraction. The style became known as the Dakar School and reached its height during the First World Festival of Black Arts (FESMAN) in 1966, with the exhibition 'Tendances et Confrontations' curated by N'Diaye. A year later N'Diaye left Senegal in profound disagreement with the direction of art under the patronage of Senghor's state and its Négritude philosophy. Nonetheless, the Dakar School came to be seen as emblematic of a postcolonial art movement that sought a unifying black identity.

Papa Ibra Tall
The Warrior, 1964
Oil on Celotax insulation
board, 134 x 104 cm
(52¾ x 63¾ in.)
Private collection

This painting of a half-human half-robot was exhibited at the First World Festival of Black Arts (FESMAN) held in Dakar in 1966. Tall then gave the work to his friend Duke Ellington who had performed at the event (see page 99).

(see page 99).

KEY ARTISTS

Amadou Bâ (b.1945), Senegal
Amadou Dédé (b.1955), Senegal
Ibou Diouf (b.1953), Senegal
Papa Ibra Tall (1935–2015), Senegal
Pierre Lods (1921–88), France
Iba N'Diaye (1928–2008), France–Senegal

KEY FEATURES

Images of African ancestry • Strong colour • Non-figurative • Lyrical abstract imagery • Promoting race awareness and pride

Overleaf: Ibou Diouf
Marché aux tissus
(Cloth market), 1964
Oil on canvas,
130 x 162 cm
(51⅛ x 63¾ in.)
Private collection

The vibrant colours in this oil painting reference African textiles and designs.

MEDIA

Painting • Sculpture • Textiles • Tapestry

KEY COLLECTIONS

Collection of the Government of Senegal, Dakar, Senegal
Museum für Völkerkunde, Frankfurt, Germany
National Art Gallery of Dakar, Dakar, Senegal
National Museum of African Art, Washington, DC, USA

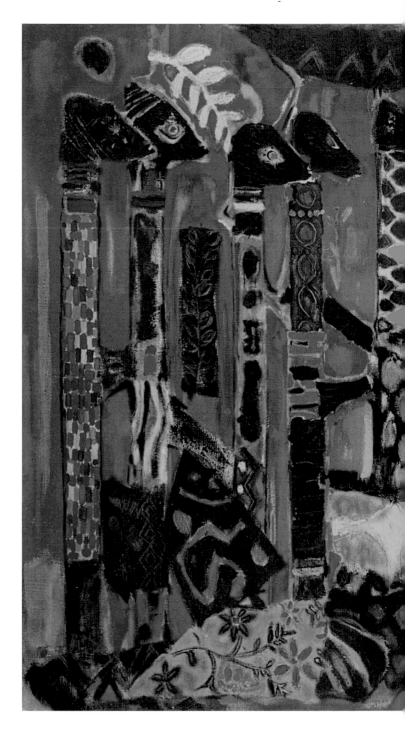

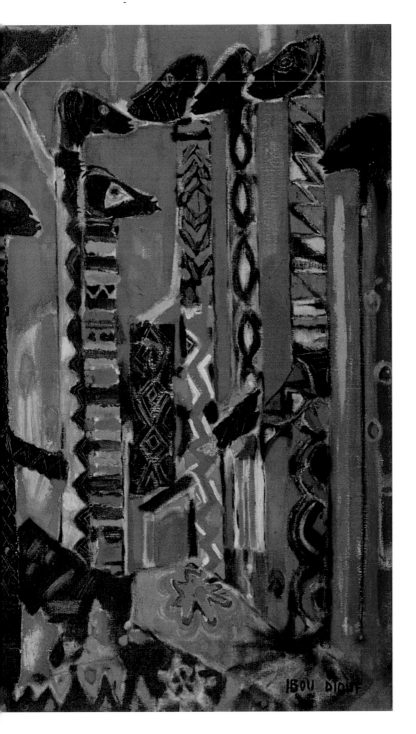

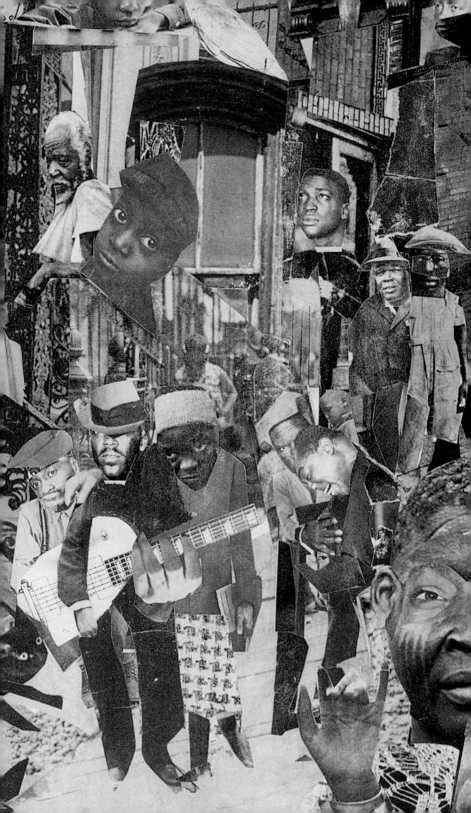

DISSIDENT IDENTITIES
AND RESISTANCE

-

Art is born out of an ill-designed world

-

Andrei Tarkovsky, 1983

EL TECHO DE LA BALLENA
1961–9

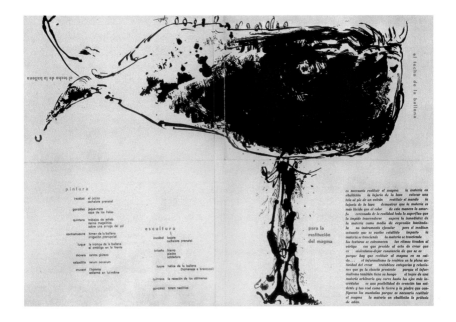

The sixty-strong collective of artists, writers and intellectuals
known as El Techo de la Ballena (The Roof of the Whale) originated
in Caracas in Venezuela in 1961 with the intention of creating an
anarchic and violent alternative to the country's art scene.

Led by the poets Juan Calzadilla and Francisco Pérez Perdomo,
the group promoted a visceral art and poetry that was designed to
shock society out of its complacency. To this end they adopted a
form of aesthetic known as Art Informel – a highly gestural form
of abstract painting that combined paint with other materials,

including detritus. This was in contrast to the highly ordered Concrete Abstraction, which at the time was favoured by the Venezuelan avant-garde.

The group were opposed to the centrist party, Acción Democrática, who were in power, and participated in protests organized by the Venezuelan Communist Party at a time when the country was emerging as an industrial power thanks to its rich oil reserves. Their first exhibition, held in a garage in Caracas in 1961, consisted of rotting animal guts and other debris that they used as a metaphor for the corruption of society.

They also published a magazine called *Rayado sobre el Techo de la Ballena* (*Stripes on the Roof of the Whale*) which promoted their incendiary ideas and explained their choice of title, writing in the third issue: 'The whale is in the middle of goodness and horror, subject to all the stresses of the world and sky.' The collective continued to promote their absurdist and unruly aesthetic over the next eight years, finally disbanding in 1969.

El Techo de la Ballena
'Para la restitución del magma' (For the Restitution of Magma) in *Rayado sobe el techo de la ballena: letras, humor, pintura* (*Stripes on the Roof of the Whale: Letters, Humour and Pictures*), Caracas, Venezuela, no. 1, 24 March 1961
Mercantil Arte y Cultura, Caracas

In 1961 the group published their provocative manifesto 'For the Restitution of Magma', in which they argued for the release of a primordial energy (a lava) that would break down social and cultural hierarchies.

KEY ARTISTS
Carlos Contramaestre (1933–96), Venezuela
Daniel González (b.1934), Venezuela
Fernando Irazábal (b.1936), Venezuela
Gabriel Morera (b.1933), Venezuela

KEY FEATURES
Debris and organic materials • Gestural • Performance • Graphic imagery • Politically charged • Visceral

MEDIA
Performance • Installation • Painting • Text and poetry • Everyday materials

KEY COLLECTIONS
Mercantil Collection, Caracas, Venezuela
Museum of Fine Arts, Caracas, Venezuela
Museum of Fine Arts, Houston, TX, USA
Museum of Modern Art (MoMA), New York, NY, USA

NEW TENDENCIES MOVEMENT
1961–73

The utopian, left-leaning New Tendencies was one of the earliest digital art movements. It was founded in the former Yugoslavia in the early 1960s by a group of international practitioners who believed art had the power to invoke radical change in society. Many of the artists came from the broader European post-Art Informel world, notably from groups such as Exat 51, Gorgona and Zero. These artists hoped that if modern art embraced new advances in computer technology and industry, it could have a positive effect on everyday life.

Their first exhibition was held in Zagreb in 1961 and featured early computer graphics, kinetic sculpture, geometric abstract paintings and visual research focusing on design and architecture. The role of the artist was replaced by that of a visual researcher, and symposiums were held in which the group's leading thinker Matko Meštrović raised questions about art's autonomy in relation to the art market, and scientists and cultural theorists debated what a future civilization might look like. Stylistically, the artworks ranged from Ivan Picelj's colourful repetitive geometric patterns to Enrico Castellani's muted monochrome reliefs.

The group emerged during a relatively prosperous time in Yugoslavia, when the country was looking outward and trying to forge links through science and technology with the west. As a result, the activities of New Tendencies were tolerated by the authorities and they continued to operate until the early 1970s, when they began to be eclipsed by other art practices. They had their last exhibition in 1973.

Julije Knifer
Gorgona no. 2, 1961
Periodical with screenprinted cover and screenprinted insert, each page 21 x 19.2 cm (8¼ x 7½ in.)
Museum of Avant-Garde, Zagreb

New Tendencies participant Knifer was also a member of Gorgona, an anti-art group who embraced absurdity and black humour in their art.

KEY ARTISTS

Enrico Castellani (1930–2017), Italy

Piero Dorazio (1927–2005), Italy

Julije Knifer (1924–2004), Croatia (former Yugoslavia)

Koloman Novak (b.1933), Croatia (former Yugoslavia)

Ivan Picelj (1924–2011), Croatia (former Yugoslavia)

Aleksandar Srnec (1924–2010), Croatia (former Yugoslavia)

Ivan Picelj
Nove Tendecije 2, 1963
Silkscreen on metallic paper, 70.5 x 50.4 cm (27¾ x 19⅞ in.)
Museum of Modern Art (MoMA), New York

Ivan Picelj was interested in creating vibrating optical effects through the use of monochrome, lighting and repeated patterns.

KEY FEATURES

Movement • Early computer graphics • Repetitive patterns • Geometry • Light • Sound

MEDIA

Painting • Sculpture • Computer graphics • Text

KEY COLLECTION

Museum of Contemporary Art, Zagreb, Croatia

DVIZHENIYE GROUP
1962–78

Dvizheniye
*Flowers and the Black
Beast*, 1972
Collection of Lev
Nussberg

**Inspired by Russian
Constructivism and
geometric abstraction,
the collective devised
colourful multimedia
performances that
were supposed to
excite the senses.**

Life as a Nonconformist artist in the USSR could be a relatively lonely experience, alienated from official art institutions and cut off from new ideas emerging in the wider world. Much of the art produced was rebellious and open-ended, in opposition to the aesthetic clichés promoted by the authorities and their portentous, definitive statements. Because there was no market for Nonconformist work and there were no collectors, there was little need to produce objects that would only clutter up the artists' apartments, and so almost by default, Nonconformist Art became experimental, focusing on the process of creativity rather than the object itself.

Out of this period came the utopian Dvizheniye Group, led by the charismatic artist Lev Nussberg. Their work took inspiration from science, kinetic art and the spatial structures of Russian Constructivism, creating experiments in light, colour, music and theatre. They staged exhibitions in which their playful kinetic constructions were presented as futuristic plans for products, taking advantage of the USSR's newly found ambitions in space. The group also devised performances, in which they wore bright, primary coloured clothing. 'To everyone, absolute freedom of imagination!' exhorted Nussberg, who held the belief that he was part of a new cosmic generation in the wake of the Soviet astronaut Yuri Gagarin. The group continued to operate under the direction of Nussberg throughout the 1960s and early 1970s, but dissolved soon after he emigrated to Germany in 1976.

KEY ARTISTS
Galina Bitt (b.1946), Russia (former USSR)
Francisco Infante-Arana (b.1943), Russia (former USSR)
Viacheslav Koleichuk (b.1944), Russia (former USSR)
Lev Nussberg (b.1937), Russia (former USSR)
Natalia Prokuratova (b.1948), Russia (former USSR)
Rimma Sapgir-Zanevskaya (b.1930), Russia (former USSR)

KEY FEATURES
Utopian • Movement • Rhythm • Light • Colour

MEDIA
Experimental sculpture • Performance

KEY COLLECTION
Moscow Museum of Modern Art, Moscow, Russia

SPIRAL
1963–5

The 1960s was a frantically rebellious and revolutionary decade, particularly in the United States, where young people, inspired by the civil rights leaders Malcolm X and Martin Luther King, said no to race discrimination and the bomb and yes to popular culture, racial solidarity and autonomy. Out of this new cultural and political atmosphere came a group of African-American artists who sought to question what it meant to be a black artist in the context of the civil rights movement.

Founded in New York in 1963, at the studio of Romare Bearden, the artists of Spiral – named by Hale Woodruff to reflect the artists' desire to 'move outward embracing all directions, yet constantly forward' – met to discuss what a black aesthetic might look like. Bearden was keen the group should work collaboratively and suggested the group produce collages that reflected the political realities experienced by the black community. This was rejected by the Abstract Expressionist members of Spiral, who were concerned about surrendering aesthetic considerations to political protest. Their one and only exhibition was held in 1965 at 147 Christopher Street in New York and featured artworks limited to black and white in deference to the civil rights crusade.

Spiral disbanded later that year following philosophical disagreements about which direction the group should take. Yet the artists of Spiral went on to form influential groups as part of the wider Black Arts Movement. Bearden and Norman Lewis founded the Cinque Gallery in New York, while Emma Amos became an active member of a well-known but anonymous feminist underground art collective.

Emma Amos
*Sandy and
her Husband*, 1973
Oil on canvas,
112.4 x 127.6 cm
(44¼ x 50¼ in.)
Cleveland Museum
of Art, Ohio

After *Spiral*, Amos
continued to paint
domestic scenes from
a feminist perspective.
This intimate scene of
a loving couple is not
as private as it appears;
Amos has painted herself
into the picture, in a
self-portrait that hangs
on the wall.

KEY ARTISTS

Emma Amos (b.1938), USA
Romare Bearden (1911–88), USA
Norman Lewis (1909–79), USA
Hale Woodruff (1900–80), USA

KEY FEATURES

Political protest • Realism and social commentary
• Non-representational • Monochrome

MEDIA

Collage • Painting • Printmaking

KEY COLLECTIONS

Brooklyn Museum, New York, NY, USA
Museum of Modern Art (MoMA), New York, NY, USA
Smithsonian American Art Museum, Washington, DC, USA

Romare Bearden
The Street, 1965
Printed papers
on cardboard,
32.7 x 39.1 cm
(12⅞ x 15⅜ in.)
Milwaukee Art Museum,
Milwaukee

**Bearden originally trained
as a mathematician,
before studying art with
the German Expressionist
George Grosz. His
narrative collages of
everyday street life
were constructed from
photojournalist imagery.**

AKTUAL ART
1964–70s

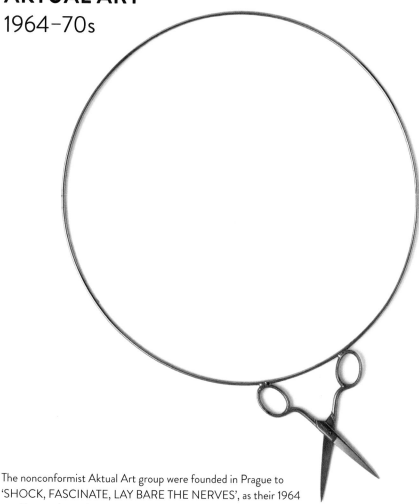

The nonconformist Aktual Art group were founded in Prague to
'SHOCK, FASCINATE, LAY BARE THE NERVES', as their 1964
manifesto exhorted. In other words, they aimed to jolt individuals
out of their comatose state by little acts of protest and intervention.
Art, they believed, should inspire wonder and surprise. They were
against the official art of the state, Socialist Realism, which they
believed to be backward-looking, and in favour of an art based
on participatory actions that would rejuvenate the culture of the
former Czechoslovakia and beyond.

To this end they devised one-off, spontaneous events that
were difficult for the authorities to control. In one famous action
of 1966, artist, writer and musician Milan Knížák and artist Jan
Mach created an intervention on a randomly selected apartment

Milan Knížák
Necklace, 1968
Iron and scissors, 41.3 x
30.2 cm (16¼ x 11⅞ in.)
Museum of Modern Art
(MoMA), New York

**Aktual Art sought
to make work that
was compellingly
provocative – a revolt
against authority and
consumerist culture.**

building in Prague, whereby they posted unmarked packages to the residents and devised installations in the hallways. Inevitably such actions attracted the attention of the police and Knížák in particular remained under police surveillance for many years.

The group – of whom anyone could be a member so long as they desired to be different – had close ties to the international Fluxus Movement, although Knížák rejected the actions of Fluxus artists as too theatrical and not rooted in everyday life. The group's writings were published in the illegal underground art journal *Contemporary Art* (*Aktualní umêni*) which was privately distributed. Aktual Art continued to operate in an ad-hoc way, promoting street actions and festivals and, after Knížák was forced to leave Prague in 1967, through the Aktual music band. On his return, Knížák became the controversial director of the National Gallery of Prague until 2011.

KEY ARTISTS

Milan Knížák (b.1940), Czech Republic
Jan Mach (b.1943), Czech Republic
Vit Mach (b.1945), Czech Republic
Sona Šecová (b.1946), Czech Republic
Jan Trtílek (b.1938), Czech Republic

KEY FEATURES

Absurdity • Site specific • Use of non-art materials •
Taking inspiration from everyday life • Protest and resistance
• Nonconformist

MEDIA

Street Happenings • Performance • Underground *samizdat*
publishing • Mail art • Music

KEY COLLECTIONS

Museum of Czech Literature, Prague, Czech Republic
Museum of Modern Art (MoMA), New York, NY, USA
National Gallery of Prague, Prague, Czech Republic

OHO MOVEMENT
1965–71

The highly inventive conceptual OHO Movement began in the early 1960s in the Slovenian city of Kranj in the former Socialist Federal Republic of Yugoslavia. OHO is a combination of the words *oko* (eye) and *uho* (ear), as well as being a statement of surprise. Founded by the Concrete poet Iztok Geister and visual artist and poet Marko Pogačnik, it was a radical and subversive art movement

Marko Pogačnik
*Matchbox Labels –
Bottle Tops*, 1967/1994
Matchboxes and coloured
paper, 5.3 x 3.6 cm
(2⅛ x 1⅜ in.) each
Moderna galerija,
Ljubljana

**OHO believed that
artworks should be
liberated from the grip
of cultural institutions.
To do this, Pogačnik
bought matchboxes and
pasted OHO labels over
the original ones before
reselling them at the
same price.**

that combined existential philosophy, language and art to create performances, texts and installations that were as absurd in the Dadaist sense as they were utopian. OHO produced short films such as *White People* (1970) directed by the group's most prolific filmmaker Naško Križnar, in which white performers dressed in white clothes would interact with white animals and white objects until they finally merged into white backgrounds. The art was rooted in the Slovenian idea of *reism*, which means 'a return to things themselves', an idea that attracted philosophers and writers to work with them. Much of their art confronted the contradictions and complications of living in a socialist state, one that had relative freedom compared to other Eastern European countries, yet still forced them to operate on the fringes of official culture.

By 1970 OHO had conceived of the idea of 'transcendental conceptualism', which means art that exists beyond the boundaries of human experience, and as a result they virtually stopped making art altogether. Pogačnik founded a commune near the village of Šempas, and art became subsumed by the practicalities of everyday farming life.

KEY ARTISTS
Iztok Geister (b.1945), Slovenia
Naško Križnar (b.1943), Slovenia
Milenko Matanovič (b.1947), Slovenia
David Nez (b.1949), USA–Slovenia
Marko Pogačnik (b.1944), Slovenia
Andraž Šalamun (b. 1947), Slovenia
Tomaž Šalamun (1941–2014), Slovenia

KEY FEATURES
Happenings • Anti-form art: making works that could not be defined as objects • Absurdist • Text and poetry

MEDIA
Film • Performance • Materials • Actions

KEY COLLECTION
Museum of Contemporary Art Metelkova, Ljubljana, Slovenia
Museum of Modern Art (MoMA), New York, NY, USA

MASS-MEDIATIC ART
1965–8

Roberto Jacoby, Eduardo Costa and Raúl Escari
First Mass-Mediatic Artwork, 1966
Photocopies, 30.5 x 23 x 1.9 cm (12 x 9 x ¾ in.)
Roberto Jacoby Archives, Buenos Aires

An image from the fictitious Happening. It led to various discussions in the media about whether it was a sociological experiment, a conceptual artwork or a literary joke.

In 1966 three conceptual artists from Buenos Aires put out a press release describing a performance that had occurred in the city in which a number of high-profile personalities had participated. The work, *Happening for a Dead Wild Boar,* was duly reported in the press, only for it to be discovered later that the performance had never taken place. The artists involved, operating under the title Mass-Mediatic Art (Arte de los Medios de Comunicación Masivos), explained that in today's society most people did not come into contact with culture first hand, but rather through the media, via televised broadcasting or newsprint: 'The truth is that consumers of information do not care if an exhibition is carried out or not; the only thing that matters is the image of the artistic event *rebuilt* by the mass media.'

The performance had been partly inspired by the writings of the Canadian philosopher Marshall McLuhan, and his theory that 'the medium is the message', in other words, the meaning varies depending on its characteristics and how it is disseminated to the public. Over the next few years the group continued to use the mass media as their medium and the subject of their artwork, to create a number of conceptual events in the city. Most notably, in 1968 the Vanguard Artists Group hoodwinked the media into reporting on the appalling conditions experienced by inhabitants of Tucumán by staging a mock international arts festival.

KEY ARTISTS
Eduardo Costa (b.1940), Argentina
Raúl Escari (b.1944), Argentina
Roberto Jacoby (b.1944), Argentina

KEY FEATURES
Conceptual • Collaborative • Experimental • Political

KEY MEDIA
Mass media

KEY COLLECTIONS
Museo de Arte Moderno de Buenos Aires, Buenos Aires, Argentina
Museo Nacional Centro de Arte Reina Sofia, Buenos Aires, Argentina

CARIBBEAN ARTIST MOVEMENT
1966–72

Althea McNish
Tepeaca, 1961
Printed cotton,
50 x 95 cm
(19¾ x 37⅜ in.)
Cooper-Hewitt,
Smithsonian
Design Museum,
Washington, DC

Althea McNish took her inspiration from nature and society, combining verdant Caribbean plant life with the vibrancy of Sixties pop culture.

The Caribbean Artist Movement (CAM) was a proactive collective founded in London in 1966 by the Caribbean poets John La Rose, Edward Kamau Braithwaite and Andrew Salkey so that black poets, writers and artists could connect with one another. At the centre of the movement was the charismatic Trinidad publisher and polemicist La Rose, who, together with activist Sarah White, had set up New Beacon Books in 1966, an independent publishing house that promoted writers from the African diaspora. From their base in Stroud Green, North London, New Beacon Books offered the children of the Windrush generation – or, as La Rose called them, the 'heroic generation' – the chance to discover their literary and artistic heritage. La Rose had been an anti-colonial activist in Trinidad in the 1950s, who had recognized the need to fill the gaps in the Caribbean's literary history. Thus he began disseminating key texts that had either been banned by the authorities or were out of print, in order to challenge the existing canon.

In the early 1960s Tobago, Trinidad, Barbados and Jamaica gained independence from British colonial rule, and vibrant discussions ensued about what independence meant and what role artists should play in the establishment of a modern Caribbean aesthetic. For those intellectuals who had migrated to Britain, further discussions were raised about identity and how they should best represent themselves. The movement started the journal *Savacou* to shed light on artists and writers from the Africa diaspora ignored by the British establishment.

A key artist in the movement was Ronald Moody, who was responsible for the magazine's motif, a Carib bird-god that appeared on the fly leaf. His modernist wood-carvings combined allegorical themes with Egyptian, Chinese, Indian and Pre-Columbian influences (overleaf). By 1960 he was already a successful sculptor but he joined the group in order to assist other artists in combating racial prejudice and discrimination in Britain. He supported exhibitions that raised the profile of Caribbean artists, most notably the 'Caribbean Artists in England' exhibition at the Commonwealth Institute in London in 1971. Later he was active in organizing the British delegates to the FESTAC '77, the second World Black and African Festival of Arts and Culture in Lagos, Nigeria, and he participated in curator and artist Rasheed Araeen's pioneering 1989–90 exhibition 'The Other Story: Afro-Asian Artists in Post-War Britain' at the Hayward Gallery in London, which helped to bring recognition to the work of African and Asian artists in Britain.

As new immigration and race relations acts were imposed in the wake of the racist rhetoric coming out of Britain in the late

1960s and early 1970s, groups such as CAM helped to strengthen the resolve of young black authors and artists in their fight for political and cultural autonomy and to boldly document the lives of West Indian migrants. The movement had a profound influence on later generations, with Braithwaite and others now considered the forefathers of Dub poetry (performance poetry of West Indian origin). Artists, such as Althea McNish, who drew on the mythologies and colours of the Caribbean in their art, have had an enduring impact on later black artists, as well as bringing tropical colour to British textiles (page 94).

Ronald Moody
Midonz, 1937
Elm wood, 69 x 38 x 39.5
cm (27⅛ x 15 x 15¼ in.)
Tate, London

This sculpture represents a primordial woman who is in the process of transforming from physical matter into spiritual form. It was inspired by Pre-Columbian art and Egyptian carving.

KEY ARTISTS

Karl Broodhagen (1909–2002), UK (born Barbados)
Paul Dash (b.1946), UK (born Barbados)
Donald Locke (1930–2010), UK (born Guyana)
Ronald Moody (1900–84), UK (born Jamaica)
Althea McNish (b.1933), UK (born Trinidad)
Aubrey Williams (1926–90), UK (born Guyana)

KEY FEATURES

Forms, symbols and images from the Caribbean or Pre-Columbian art • Bold, geometric designs • African motifs • Reflecting racial and political struggles • Memory • Resistance • Search for a Caribbean British identity

KEY MEDIA

Sculpture • Printmaking • Painting • Text

KEY COLLECTIONS

Guyana National Museum, Georgetown, Guyana
Tate, London, UK
Victoria and Albert Museum (V&A), London, UK

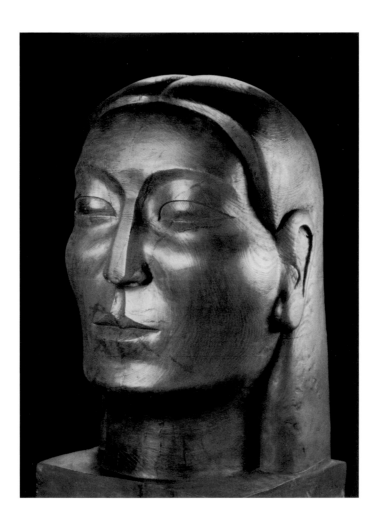

PAN-AFRICANISM
1966–77

When Bob Marley sang the words 'emancipate yourself from mental slavery, none but ourselves can free our minds', he was in fact quoting the black activist and theoretician Marcus Garvey who, in the 1920s, promoted an ideology known as pan-Africanism. The essence of this was the idea that all peoples of African descent shared a common cultural heritage, and that collective black consciousness should be fostered in order to forge the bonds of solidarity necessary to overcome the legacies of slavery and colonialism.

Pan-Africanism was not a new idea in the 1920s; it had been around since the mid-nineteenth century and had been widely promoted by the pioneering civil rights activist W. E. B. Du Bois. However, it did not gain traction until the early 1900s, with pan-African congresses meeting to discuss how to secure African independence and fight racism. This was not just a political fight, it was cultural too. Artists, writers and musicians played their part, most notably those associated with Surrealism, such as the visionary Afro-Caribbean group Légitime Défense and the influential Négritude Movement who related Surrealism and its revolutionary ideas to pan-African thinkers such as Du Bois, Garvey and Langston Hughes.

In the optimistic atmosphere of many African countries immediately after they had won independence in the mid-twentieth century, this desire to forge unity became a key policy. In 1966 the First World Festival of Black Arts (FESMAN) took place in Dakar, Senegal. It was a highly symbolic moment for the pan-African cultural movement: one that gave cultural expression to the liberated, and fellowship and solidarity to those still fighting for civil rights in places, such as the United States. Over the course of a month musicians, poets, actors, writers and artists from all over

Press photographer
Duke Ellington at FESMAN, Dakar
Photograph released in April 1966

In 1966 President Léopold Sédar Senghor created the First World Festival of Black Arts (FESMAN) in Dakar. Thousands of artists across Africa and its diaspora travelled to take part, including American-born French entertainer Josephine Baker and the American musician Duke Ellington.

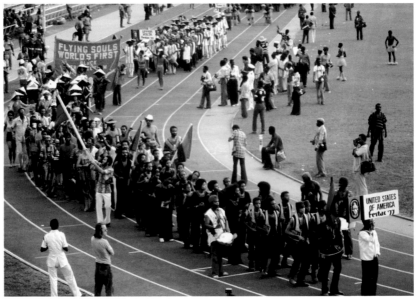

Press photographer
Regatta at
FESTAC '77, Lagos
Photograph
Helinä Rautavaara
Museum, Espoo (Finland)

**FESTAC '77 was a
week-long celebration of
African culture held in
Lagos. Fifty-six nations
participated in the
vibrant and optimistic
festival that spanned
visual and performing
arts, music, literature,
poetry and fashion.**

the African diaspora participated and collaborated in one of the
brightest, liveliest and most hopeful festivals of the decade. Three
years later, a manifesto was developed during the more radical
Pan-African Cultural Festival of 1969 in Algiers. While the ideology
of pan-Africanism lost momentum, the World Festival of Black
Arts continues today. Perhaps its most famous manifestation is
the second World Black and African Festival of Arts and Culture
(FESTAC '77). It was held in 1977 in Lagos in Nigeria, where artist
delegations from all over Africa and the African diaspora attended,
marching through the city's stadium in a show of cultural unity.

KEY ARTIST GROUPS

Artist delegations from all over Africa and
 the African diaspora including:
AfriCOBRA, Chicago, USA
Caribbean Artist Group
École de Dakar, Senegal
Laboratoire Agit'Art, Dakar, Senegal
Négritude
Zaria Rebels, Zaria, Nigeria

Press photographer
Opening ceremonies at
FESTAC '77, Lagos
Photograph
Helinä Rautavaara
Museum, Espoo (Finland)

KEY FEATURES

Optimism • Cultural unity • Political diplomacy • Civil rights

**Over 17,000 people
participated in this
state-sponsored festival.**

MEDIA

Visual arts • Performance • Poetry • Music

KEY EVENTS

First World Festival of Black Arts (FESMAN), Dakar, Senegal, 1966
Pan-African Cultural Festival, Algiers, Algeria, 1969
Second World Black and African Festival of Arts and Culture
 (FESTAC), Lagos, Nigeria, 1977

101

MONO-HA
1967–74

Takamatsu Jirō
Shadow of the Baby No. 122 (Akanbo no kage No. 122), 1965
Acrylic on canvas, 181.9 x 227 cm (71⅝ x 89⅜ in.)
Toyota Municipal Museum of Art, Toyota

From Takamatsu Jirō's shadow painting series, this picture recalls the imprints of figures left on walls after the annihilation of Hiroshima and Nagasaki by atomic bombs.

The influential post-war movement Mono-ha (School of Things) was a loose association of artists that emerged in Japan in late 1967, during a period rocked by student protests and strikes against Japan's continued security treaty with the United States. This grass-roots activism culminated in 1968, with the anti-war rally against the Vietnam War. Many of the artists associated with Mono-ha had studied at Tokyo's Tama Art University, one of the universities at the centre of these protests, and their art was made partly in response to the society-wide instability they witnessed around them.

The name Mono-ha was never used by the artists themselves, in fact it was a term applied to them disparagingly by critics in the early 1970s who considered their art to be too slight and inconclusive for consideration. The group's key theorist, the Korean-born Lee Ufan, moved to Japan in the late 1950s to study philosophy before becoming an artist. He joined Mono-ha after writing an essay about the sculpture *Phase-Mother Earth* (1968) created by Sekine Nobuo.

Together, they worked to create a modern sculptural language using raw materials, such as stone, sand, wood and metal, that they constructed into ephemeral, site-specific installations that could not be bought or sold. In fact, many of their works were dismantled soon after they were exhibited, making photographic documentation crucial in recording the art. In this respect, their philosophy was similar to that of the Italian art movement Arte Povera, with its focus on everyday materials and its rejection of traditional ideas of art making. Neither group, however, were particularly aware of the other's existence at this time.

Arguably, at the heart of Mono-ha's practice was a question about what to make. Ufan later explained the dilemma as a protest against the rapid advances of modernism. Work was typified by its restrained and contemplative philosophy. Organic and man-made objects were placed in such a way as to animate the space around them. They would be stacked, suspended or simply propped against a wall, in order to emphasize their nonhierarchical nature. Ufan used the word *chūto hanpa*, meaning unresolved or incomplete in Japanese, to describe the group's experimental aesthetic. These poetic meditations were not appreciated by everyone. The activist Bikyōtō Movement argued that the artists were too metaphysical and not fully engaged with the political realities happening in the country. Yet by the late 1980s, Mono-ha were recognized as a significant movement in Japan with Lee Ufan becoming one of the most successful artists in the world.

KEY ARTISTS

Enokura Kōji (1942–95), Japan
Koshimizu Susumu (b.1944), Japan
Lee Ufan (b.1936), Korea
Sekine Nobuo (1942–2019), Japan
Suga Kishio (b.1944), Japan
Takamatsu Jirō (1936–98), Japan

KEY FEATURES

Raw materials • Simple gestures • Minimal • Objects in relation to their surroundings • Contemplative • Art of encounter • Site specific • Ephemeral

Koshimizu Susumu
Paper (formerly Paper 2),
1969/2012
Paper and granite,
paper: 274.3 x 274.3 cm
(108 x 108 in.); stone:
57.2 x 163.8 x 162.6 cm
(22½ x 64½ x 64 in.)
Blum & Poe, Los Angeles

**Here, Koshimizu Susumu
contrasts the physicality
of both objects: the
heavy hunk of stone
is enveloped by a thin
membrane of Japanese
handmade paper.**

Sekine Nobuo
Phase-Mother Earth,
1968/2012
Earth and cement,
270 x 220 cm
(106¼ x 86⅝ in.);
hole 270 x 220 cm
(106¼ x 86⅝ in.)
Blum & Poe, Los Angeles

**Sekine's artwork involved
digging a hole and using
the earth to create a
perfect cylinder by
fortifying the matter
with cement and
compacting it into a
mould. The sculpture
stood next to the void
created by its absence.**

MEDIA

Stone • Metal • Sand and earth • Wood • Paint and canvas

KEY COLLECTIONS

Collections of the National Art Museums, Japan

Lee Ufan Museum, Naoshima Island, Japan

National Museum of Modern Art, Tokyo, Japan

The Rachofsky House Collection, Dallas, TX, USA

MURAL MOVEMENT
1967–75

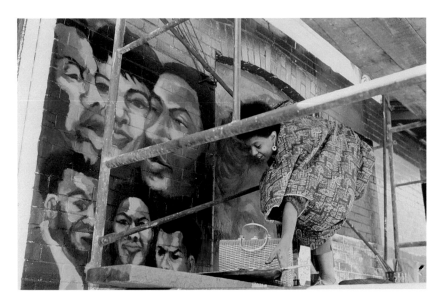

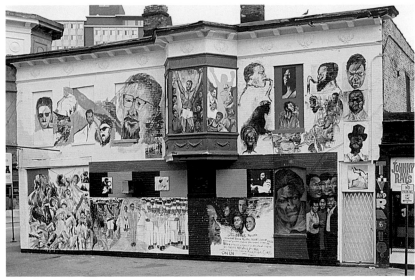

Robert Abbott Sengstacke
OBAC's planning meeting, summer 1967
Photograph

OBAC participating in an early planning meeting of the Visual Arts Workshop in Chicago. From left to right, back row: unidentified artist, artist William Walker. Left to right, front row: graphic designer Sylvia Abernathy and artists Jeff Donaldson and Edward Christmas.

Opposite, above:
Barbara Jones-Hogu
The Wall of Respect, 1967
Photographed by
Robert Sengstacke
Chicago

AfriCOBRA founder member Barbara Jones-Hogu is on the scaffolding painting *Theatre* mural, which included a portrait of Oscar-winning actor Sidney Poitier.

Opposite, below:
Various artists
The Wall of Respect, 1967
Paint on wall
Chicago

Painted on a condemned building on 43rd Street and Langley Avenue, the Wall of Respect was completed on 24 August 1967. There followed a dedication ceremony featuring live music and poetry readings by Gwendolyn Brooks and Don L. Lee.

The nationwide Mural Movement began in 1967 in the United States, when the artists of the civil rights Organization of Black American Culture (OBAC) painted a giant outdoor mural on Chicago's South Side. This mural, which depicted black heroes, came to be known as the Wall of Respect. It was divided into seven sections: statesmen, sports, jazz, rhythm and blues, religion, literature and theatre. The historian Lerone Bennett Jr, who was one of the figures depicted, wrote later that 'For a long time now it has been obvious that Black Art and Black Culture would have to go home. The Wall is Home and a way *Home*.'

The mural inspired other artists across the country to paint their own walls on themes relating to black culture in the hope it would unite disparate African-American communities. In 1972 in Boston, the artist activists Dana C. Chandler Jr and Gary Rickson painted Black Panther leader Stokey Carmichael and African motifs, and used brightly coloured Social Realist murals to empower black communities with slogans such as 'Knowledge is Power', 'Stay in School'. Others, such as the Harlem-based Smokehouse Associates, chose to create abstract images on the sides of buildings, arguing that rather than making art about change, their paintings were the change and improved the environment for the better (see page 109).

Many of the artists had been inspired by the pioneering work of early Harlem Renaissance artists Charles Alston and Hale Woodruff, who had been commissioned to paint murals that addressed the history of African-Americans during the New Deal era in the 1930s.

Woodruff's Amistad murals could be found in the Savery Library at
Talladega College in Alabama, while Alston painted murals for Harlem
Hospital. In 1971, after a fire destroyed the building,
the Wall of Respect was torn down but, nevertheless, its history
remains a potent symbol of black activism.

Smokehouse Associates
Artwork on wall,
c.1968–70
Photographed by
Robert Colton
Michael Rosenfeld
Gallery LLC, New York

KEY ARTISTS

Cleveland Bellow (1946–2009), USA

Dana C. Chandler Jr (b.1941), USA

Jeff Donaldson (1932–2004), USA

Melvin Edwards (b.1937), USA

Jae Jarrell (b.1935), USA

Wadsworth Jarrell (b.1929), USA

Barbara Jones-Hogu (1938–2017), USA

Gary Rickson (b.1942), USA

Smokehouse Associates was formed in Harlem in 1968 by Guy Ciarcia, Melvin Edwards, Billy Rose and William T. Williams.

William Walker (1927–2011), USA
William T. Williams (b.1942), USA
Hale Woodruff (1900–80), USA

KEY FEATURES

Optimistic • Social Realism • Slogans • Depictions of powerful black heroes • Non-representational design • Colour

MEDIA

Mural painting

KEY SITES

Amistad Mutiny murals, Savery Library, Alabama, USA
Harlem Hospital murals, Harlem, USA
Studio Museum, Harlem, USA

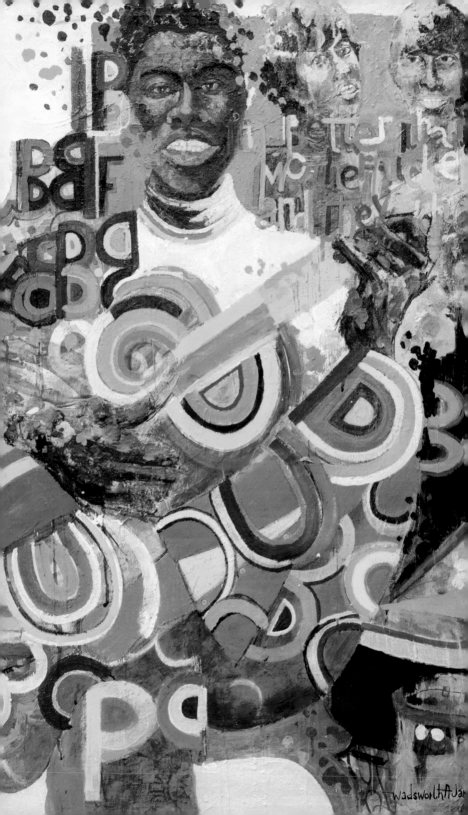

IDENTITY AND TRANSNATIONALISM

-

The noise of our living boxed in stone and steel
is so loud that even a pistol shot is smothered

-

Richard Wright, 1941

AOUCHEM MOVEMENT
1967–71

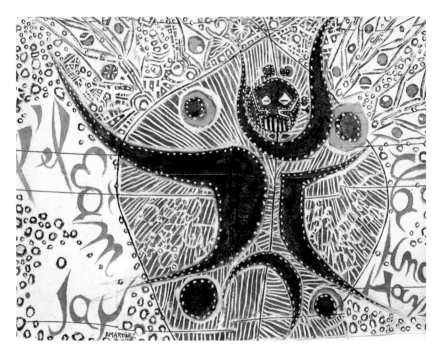

Denis Martinez
*See You Next Year
If We Are Alive*, 1966
Composed of six
floorcloths, 120 x 200 cm
(47¼ x 78¾ in.)
Collection of the artist

The Aouchem artists
also drew inspiration
from the remarkable
figures in prehistoric
cave paintings of the
Tassili mountains in
the Sahara desert,
found in the 1930s.

The relatively short-lived Aouchem Movement was formed in Algeria in 1967, in the immediate postcolonial period. The bloody struggle for the country's independence, the guerrilla warfare and its brutal repression by the French military was one of the most violent colonial conflicts in modern history, lasting from 1954 to 1962. In the war's aftermath, with the establishment of an independent Algeria, artists, writers, musicians and poets sought to develop a cultural identity that would liberate Algerian art from French colonial influences.

The artists of the Aouchem Movement sought an Algerian aesthetic by looking towards the indigenous arts of the past. They adopted the word '*Aouchem*', meaning tattoo in Arabic. They saw it as symbolic of something that cannot be erased, which was important in the context of colonialism, as well as because it referred to the body art of the indigenous Berber people (Imazighen) of North Africa. The artists incorporated the traditional Berber designs, together with wall paintings and jewellery design, into their abstract paintings, arguing that western abstraction had ignored the influence of eastern and African geometric design. The group were outward-looking and ideologically inspired by the pan-African movement, which sought to create a united Africa through culture. They held their first exhibition in Algiers in 1967 and continued to operate until 1971. In 1993, with the outbreak of the civil war, several of Aouchem's founders left the country.

KEY ARTISTS
Hamid Abdoun (1929–98), Algeria
Mustapha Akmoun (b.1946), Algeria
Denis Martinez (b.1941), Algeria
Choukri Mesli (b.1931), Algeria
Rezki Zerarti (b.1938), Algeria

KEY FEATURES
Berber designs and tattoos • Non-representational • Geometric design • Bright, intense colours inspired by Berber fabrics

MEDIA
Mixed media • Ink • Bark • Pigments • Performance • Painting

KEY COLLECTIONS
Museum of Modern Art, Algiers, Algeria

BIKYŌTŌ
1968–74

The word Bikyōtō comes from the Japanese phrase *Bijutsuka Kyōtō Kaigi*, meaning Artists' Joint Struggle, which describes the politically active group of young left-leaning Japanese artists who instigated a ten-month occupation of Tokyo's Tama Art University in 1969. The protest grew out of the larger nationwide Zenkyōtō Movement, which had begun a year earlier at the University of Tokyo when students barricaded the institution in a demonstration against Governor Minobe's rule.

Like many of the students protesting across the country, the artists of Bikyōtō were alarmed by the rampant commercialization and environmental damage caused by rapid modernization in Japan. In 1971, after the student movement had collapsed, the collective reformed as the Bikyōtō Revolution Committee and began an inquiry into the institutional structures that supported the country's art establishment. As part of the non-art movement, they disrupted large-scale exhibitions and created Happenings on the street, where they believed art belonged rather than in a museum. In 1974 the group stopped making art altogether when they entered an agreement of non-activity for a year.

Hikosaka Naoyoshi
Invitation to Floor Event, 1971
Postcard,
10 x 14.5 cm
(3⅞ x 5¾ in.)

An invitation to one of Hikosaka's poured latex performances. In 1970 Hikosaka covered his bedroom floor with latex and then lived in the room for nine days while it dried. He made variations of this floor series for the next five years, until the floor (which had been dismantled and shipped to the Paris Biennale) was confiscated by Japanese customs and destroyed.

KEY ARTISTS
Hikosaka Naoyoshi (b.1946), Japan
Hori Kōsai (b.1947), Japan
Ishiuchi Miyako (b.1947), Japan
Miyamoto Ryūji (b.1947), Japan
Tone Yasunao (b.1935), Japan
Yamanaka Nobuo (1948–82), Japan

KEY FEATURES
Direct action • Resistance • Research • Anti-art
• Unconventional materials • Collaboration • Text

MEDIA
Performance • Video • Photography • Installation

KEY COLLECTIONS
Museum of Contemporary Art, Tokyo, Japan
National Museum of Art, Osaka, Japan
Setagaya Art Museum, Tokyo, Japan

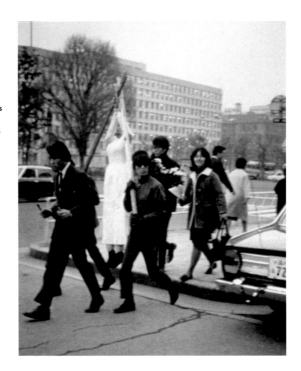

Hori Kōsai
*Self-Burial
Ceremony*, 1967
Photographic
documentation of a
performance

With the help of his peers
at Tama Art University,
this walking performance
from Tokyo Station to
the Ginza area launched
Hori Kōsai's career
as an artist. Hori was
active in the Japanese
student demonstrations
of the late 1960s
that challenged the
institutionalized nature
of art.

AFRICOBRA
1968–77

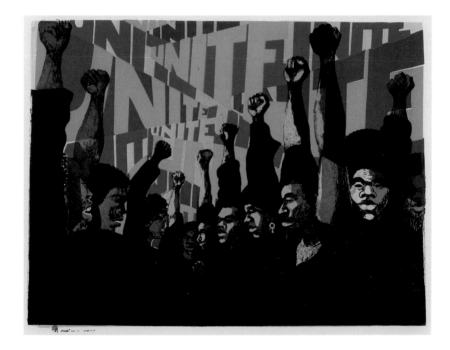

Of the great Black Power art groups in the United States, few
were more influential than the African Commune of Bad Relevant
Artists (AfriCOBRA), the Chicago-based movement formed
in 1968 to breathe a new aesthetic into the world in the wake of
the assassinations of civil rights activists Martin Luther King and
Malcolm X. Many of the artists associated with AfriCOBRA had
been involved in the civil rights movement and were participants
in Chicago's Organization of Black American Culture (OBAC),
and had worked on the community mural Wall of Respect in 1967,
through which it was hoped African-American communities would
be empowered (see pages 106–9).

Opposite: Barbara
Jones-Hogu
Unite, 1971
Screenprint on paper,
57.2 x 76.2 cm
(22¼ x 30 in.)
Brooklyn Museum,
New York

In 1973 Barbara Jones-Hogu identified the visual elements of AfriCOBRA as 'bright colours, the human figure, lost and found line, lettering, and images which identified the social, economical and political conditions of our ethnic group'.

In his essay 'Ten in Search of a Nation', AfriCOBRA founding member Jeff Donaldson set out what this new black aesthetic should be: one that would combine influences from Africa with those from America. Images would have rhythm and be inspired by African music and movement; there would be a vibrant palette of orange, strawberry, cherry, lemon, lime and grape that corresponded with the flavours of the soft-drink Kool-Aid; political slogans would be incorporated and, finally, '*Shine* – we want the things to shine, to have the rich lustre of a just-washed "fro" of spit-shined shoes . . .' The group created posters and paintings that contained positive messages for the black community; they were celebratory and 'super-real' – the term the group used to describe their heightened form of Surrealism.

Artist Barbara Jones-Hogu expanded on Donaldson's essay with the group's manifesto *The History, Philosophy and Aesthetics of AfriCOBRA* for the exhibition 'AFRI-COBRA III' held at the University of Massachusetts, Amherst, in September 1973. The group continued operating until the late 1970s, also participating in the pan-African cultural festival FESTAC in Nigeria in 1977.

Jae Jarrell
Revolutionary Suit, original
1969, remade 2010
Wool, suede, silk, wood
and pigment, 88.9 x
68.6 x 30.5 cm
(35 x 27⅛ x 12 in.)
Brooklyn Museum,
New York

Jae Jarrell's revolutionary fabric sculptures were designed to empower the wearer. This tweed suit has a scalloped edge that is suggestive of an ammunition belt, yet the tubes inside resemble oil pastels.

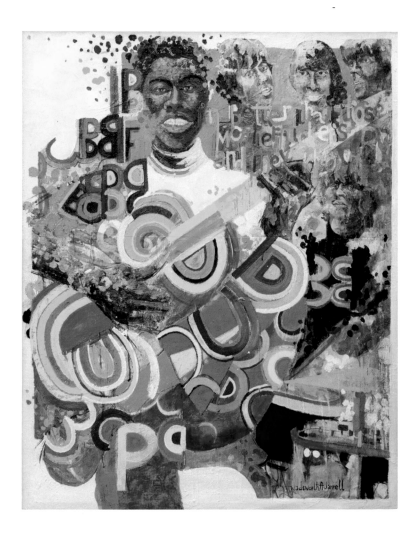

KEY ARTISTS

Sherman Beck (b.1942), USA

Jeff Donaldson (1932–2004), USA

Napoleon Henderson (b.1943), USA

Jae Jarrell (b.1935), USA

Wadsworth Jarrell (b.1929), USA

Barbara Jones-Hogu (1938–2017), USA

Carolyn Lawrence (b.1940), USA

Nelson Stevens (b.1938), USA

Gerald Williams (b.1941), USA

Wadsworth Jarrell
*I Am Better than
those Motherfuckers
and They Know It*, 1969
Acrylic on canvas,
37 x 45 cm
(12 x 14⅞ in.)
Studio Museum,
Harlem, New York

**AfriCOBRA met
regularly and chose
themes for their art, such
as the black family group
and 'I Am Better than
those Motherfuckers'.**

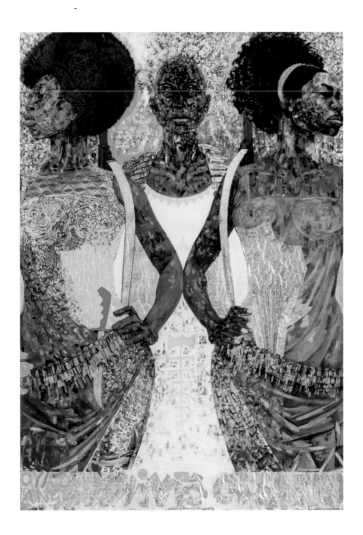

Jeff Donaldson
Wives of Sango, 1971
Acrylic paint, gold foil and
silver foil on cardboard,
91.4 x 61 cm (36 x 24 in.)
National Museum of
African American
History and Culture,
Washington, DC

**This painting depicts the
three wives of Shango,
the god of thunder for
Nigeria's Yoruba people;
it celebrates female
empowerment.**

KEY FEATURES

Vibrant colours • Figurative • African motifs • Graphic lettering
• Political slogans • Geometric designs

MEDIA

Paint • Printmaking • Mural

KEY COLLECTIONS

Brooklyn Museum of Art, New York, NY, USA
National Museum of African American History and Culture,
 Washington, DC, USA

NEW VISION GROUP
1969–72

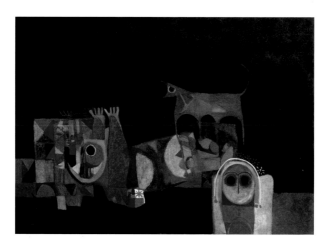

Pan-Arabism was a political and cultural ideology that first gained traction during the colonial era, and then later in postcolonial times as a way of unifying and modernizing the Arabic-speaking world. For artists, it was a potent concept that could help to develop a new Arabic form of modern art. But in 1967 a trauma occurred that was to have a seismic impact on the development of cultural practices in the Arab world. The Six-Day War, in which the Israeli army defeated the Arab military and gained territory in the process, threw the Middle East into a period of internal crisis. While this marked the beginning of the end for the pan-Arabist movement, there were artistic groups that emerged in the late 1960s who saw the role of art as part of a revolutionary struggle to unite the Arab world serving humane ends.

One such group was the New Vision Group (Al-Ru'yya al-Jadidah), founded in Iraq by the painter Dia al-Azzawi in 1969. It espoused pan-Arab unity, seeking to connect artists ideologically and culturally rather than stylistically. They worked to organize art biennials and poetry festivals and staged Baghdad's cultural Al-Wasiti Festival in 1972. Most (although not all) of the artists associated with New Vision promoted an abstract form of painting as a way of expressing their freedom, which also incorporated Arabic lettering – known as 'Huroufiyah' (see pages 56–7). The group

Dia al-Azzawi
A Wolf Howls: Memories of a Poet, 1968
Oil on canvas,
84 x 104 cm (33 x 41 in.)
Barjeel Art Foundation, Sharjah

This painting was inspired by communist poet Muzaffar al-Nawab's poem about a young man who was killed in the 1963 Syrian *coup d'état* and the anguish of his grieving mother.

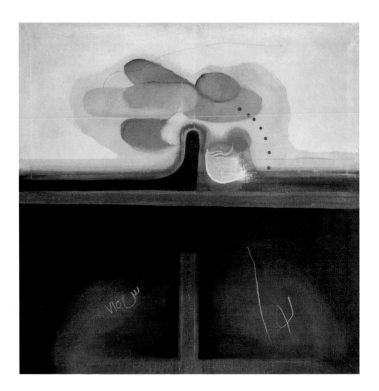

Rafa al-Nasiri
Prisoner 715, 1976
Acrylic on canvas,
95 x 95 cm
(37⅜ x 37⅜ in.)
Private collection

Founding member Rafa al-Nasiri was an activist whose works raised issues about the political situation in Iraq. In the mid-1970s he set up the Graphics Department at the Institute of Fine Arts in Baghdad.

disbanded in 1972, as the Ba'athist regime in Iraq evolved into a dictatorship, and Dia al-Azzawi left the country in 1976.

KEY ARTISTS

Dia al-Azzawi (b.1939), Iraq
Ismail Fattah (1934–2004), Iraq
Saleh al-Jumaie (b.1939), Iraq
Rafa al-Nasiri (1940–2013), Iraq

KEY FEATURES

Incorporation of Arabic letters • Mysticism • Symbolism • Bold colours • Abstract images • Expressive brushstrokes

MEDIA

Oil and acrylic paint

KEY COLLECTIONS

Barjeel Art Foundation, Sharjah, United Arab Emirates
Jordan National Gallery of Fine Arts, Amman, Jordan
Mathaf: Arab Museum of Modern Art, Doha, Qatar
National Museum of Modern Art, Baghdad, Iraq

FEMINIST VIDEO
1970s–80s

In the late 1960s, women artists and activists in Europe and the United States began making videos in order to contribute to the feminist discourse surrounding the body, sexual politics and identity. The choice to use video was, in the main, deliberate. As a relatively new media, it was free of the cultural constraints written and perpetuated by men. Video was a blank canvas onto which women could fashion their own ideas, and they did.

In Paris especially, there emerged in the early 1970s a particularly vibrant and militant period of radical femininity. Spearheaded by anti-establishment filmmakers such as Carole Roussopoulos, women formed video collectives to run workshops and share costs, equipment and ideas. Early films focused on a diversity of causes, from rape and domestic violence to abortion rights, and in particular the discrimination against women in the work place. Video makers also turned their gaze on marginalized female artists and writers. Roussopoulos documented performances by the artist Gina Pane, and recorded Valerie Solanas's notorious SCUM (Society for Cutting Up Men) manifesto.

Although there has been some debate about whether these pioneering feminist video collectives had an influence on other cinematic radicals, it is fair to say that there were certainly crossovers. The minimalist filmmaker Chantal Akerman cast the actor Delphine Seyrig of the feminist video collective Les Insoumuses in her modernist masterpiece about a single mother *Jeanne Dielman, 23 quai du Commerce, 1080 Bruxelles* (1975).

These groups, together with later collectives in other parts of France, continued to operate throughout the 1970s, confronting misogyny and sexism in the French media and recording the strikes of women factory workers. Yet they always struggled for exposure, and their films rarely reached more than a small audience.

Guy Le Querrec
Carole Roussopoulos, 1971
Photograph

Roussopoulos was a
fearless documentary
maker who depicted
the lives of women
on the periphery of
society. She was also
a close collaborator
of Chris Marker's,
appearing in his film
L'ambassade (1973).
In 1982 she founded
the Simone de Beauvoir
Audiovisual Centre in
Paris – the first media
institution devoted to
feminist history.

KEY WOMEN'S VIDEO COLLECTIVES

Les Cents Fleurs – formed 1973, Paris
Les Insoumuses – formed 1975, Paris
Vidéa – formed 1974, Paris
Vidéo oo – formed 1971, Paris
Vidéo Out – formed 1970, Paris

KEY FEATURES

Experimental • Feminist • Minimalist • Real-time • Grainy black
and white • Documentary

MEDIA

Video

KEY COLLECTIONS

Simone de Beauvoir Centre Audiovisuel, Paris, France

MOSCOW CONCEPTUALISTS
1970s–80s

Komar & Melamid
*Post Art No. 1
(Warhol)*, 1973
Oil on paint on canvas,
121.9 x 91.4 cm
(48 x 36 in.)
Ronald Feldman
Gallery, New York

**Vitaly Komar and
Aleksandr Melamid
formed Sots-Art in the
early 1970s with the aim
of creating a style that
bridged the gap between
Socialist Realism and
Pop Art. Their images
exploited totalitarian
symbols in the same way
Pop artists exploited
symbols of mass
consumerism.**

By the late 1950s, artists in communist Eastern Europe found themselves facing an increasingly stark choice: to forego creative experimentation and self-expression in order to extol the joys of communism in state-approved Socialist Realist art, or be driven underground. For some, the solution came in the form of Conceptualism. By shifting their focus away from a definite object, such as a painting or a sculpture, to something more ephemeral, they could defy socialist conformity and its depersonalization. As a result, different brands of Conceptualism began to appear across the region.

The Moscow Conceptualists emerged in the early 1970s, as the Soviet authorities became ever more critical of unofficial Soviet art. In 1974 a small open-air exhibition of unofficial art staged in a field on the outskirts of Moscow became notorious when the Soviet authorities wrecked it with bulldozers, prompting many artists to turn towards Conceptual art as a way of evading censorship. Ilya Kabakov created existential installations that he showed to people in private, while others chose to use text and performance.

The Collective Actions Group created a form of Romantic Conceptualism – a term conceived of by the writer and theorist Boris Groys to define a particularly Russian style of Conceptualism, rooted in the metaphysical. For these artists, the act of creativity needed to culminate in some form of lyrical, humanist or spiritual experience for it to be of value. They used a variety of media,

Irina Nakhova
Room 2, 1984
Photograph, gelatin-silver print on paper,
26 x 40 x 40 cm
(10¼ x 15¾ x 15¾ in.)
Collection of the artist

As an unofficial artist, Irina Nakhova was unable to exhibit in a gallery, and so she transformed her apartment into her art, covering the surfaces in white paper and layering them with black and grey shapes. This is one of four installations she made between 1983 and 1986.

including performance, installation and texts, and the audience's interaction with the work was often left to chance; in this way the artist could not be informed upon. For example, the Collective Actions Group would leave a painted tent in a forest, or an alarm bell ringing in the snow for people to stumble upon. Others, such as Lev Rubinstein, would produce note-card poems, short, seemingly analytical texts that revealed themselves to be absurd under scrutiny. Although these artists were not religious in a traditional sense, it is important to understand that the work they created was designed to make people think about existence beyond the limits of common sense, an otherworldly consciousness.

KEY ARTISTS
Nikita Alekseev (b.1953), Russia (former USSR)
Elena Elagina (b.1949), Russia (former USSR)
Ilya Kabakov (b.1933), Russia (former USSR)
Georgy Kiesewalter (b.1955), Russia (former USSR)
Vitaly Komar (b.1943), Russia (former USSR)
Aleksandr Melamid (b.1945), Russia (former USSR)
Andrei Monastyrski (b.1949), Russia (former USSR)
Irina Nakhova (b.1955), Russia (former USSR)
Lev Rubinstein (b.1947), Russia (former USSR)

KEY FEATURES
Ambiguity • Resistance • Humour • Satire • Juxtaposition of images and sounds • Non-narrative structure • Collaboration • Ephemera • Double thinking (saying one thing in public and another in private)

MEDIA
Video • Photography • Installation • Performance • Text

KEY COLLECTIONS
Garage, Moscow, Russia
Moscow Museum of Modern Art, Moscow, Russia
Tate, London, UK

Collective Actions Group
The Appearance,
13 March 1976
Performance in a field in Izmaylovskoe

Thirty audience members arrived in the remote field in Izmaylovskoe and were asked to wait and watch for something to appear. Eventually two performers emerged on the horizon and approached the participants and gave them certificates of attendance. Later the organizers questioned whether it was the performers who appeared to the audience or vice versa, raising issues of perception.

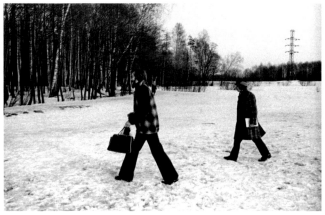

DANSAEKHWA
1970s

Dansaekhwa (Monochrome Painting) was a loosely defined Korean art movement that emerged in the 1970s during a period of economic deprivation and martial law in South Korea. The artists had all been born during Japanese colonial rule, which lasted until 1945, and were then deeply affected by the devastation caused by the Korean War (1950–53) and the subsequent division between the North and the South. This trauma was arguably reflected in their work.

The group were united in their restrained minimalist approach to painting, creating a form of abstraction that took its influence from eastern philosophy and Chinese painting. Dansaekhwa used a variety of techniques to explore the physical properties of materials. Some artists experimented with overlapping geometric patterns while others took a more metaphysical approach and played with illusion. Chung Sang-Hwa perhaps embodied Dansaekhwa's ideology best by repeatedly applying and then removing paint from the canvas until the surface formed a mottled skin.

Much has been written about the group's monochrome palette, and sometimes Danesaekhwa is referred to as the School of White. In fact, the artists were not particularly concerned with colour; it was the process of painting and its performative qualities that engaged their intellectual curiosity. Lee Ufan, for example, would drag paint down the canvas in thin lines until the pigment ran out (opposite), while Park Seo-Bo's *Ecriture* series consisted of repetitive pencil scribbles on a wet painted surface.

One of the overriding concerns for artists working in the new South Korea during the 1970s was that of national identity versus artistic identity. Which were they to pursue? There is an argument to suggest that Dansaekhwa chose a non-figurative form of art in order to avoid their works being used as political propaganda. Their decision to use cheap, easily available materials, such as hemp

Lee Ufan
From Line, 1978
Oil and mineral pigment on canvas, 60 x 72 cm (23⅝ x 28⅜ in.)
Private collection

The twenty-six lines were made in a ritualistic, repetitive way by positioning the canvas horizontally and then pulling a brush loaded with powdered cobalt blue pigment that had been dissolved in glue across the picture until the paint ran out.

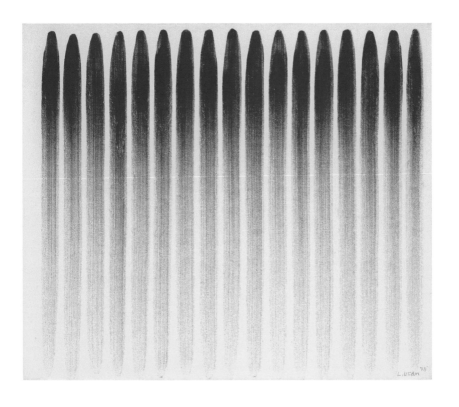

and paper, could also be seen as directly rejecting traditional Korean painting. Their subtly layered paintings arguably became a silent retort to the repressive, censorious regime the artists were living under.

Many of the artists associated with Dansaekhwa went on to teach in the country's art schools in the 1980s and 1990s, becoming a formidable influence on the history of contemporary Korean art.

Kwon Young-Woo
Untitled, 1984
Korean paper,
93 x 73 cm
(36⅞ x 28¾ in.)
Blum & Poe, Los Angeles

Kwon Young-Woo experimented with ink, letting it spread across the canvas forming pools and patterns that reflected the materiality of the surface beneath.

KEY ARTISTS

Chung Sang-Hwa (b.1932), Korea
Ha Chong-Hyun (b.1935), Korea
Hwang Hur (b.1943), Korea
Kwon Young-Woo (b.1926), Korea
Lee Dong-Youb (b.1946), Korea
Lee Ufan (b.1936), Korea
Park Seo-Bo (b.1931), Korea
Yun Hyong-Keun (b.1928), Korea

KEY FEATURES

Tightly repetitive markings • Simplified colour • Experimental use of materials • Restrained and minimal • Layering of paint • Experimenting with different painting techniques

MEDIA

Painting

KEY COLLECTIONS

Museum of Contemporary Art, Seoul, Korea
M+, Hong Kong, China
Museum of Contemporary Art, Tokyo, Japan

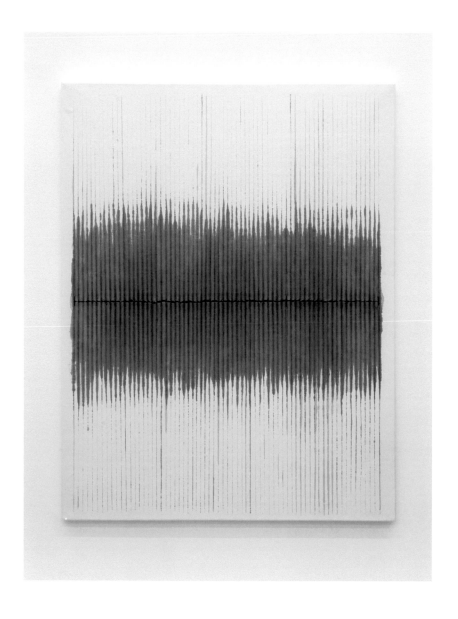

LABORATOIRE AGIT'ART
1974–2017

In 1974 a group of young Senegalese artists, writers and musicians established a loose collective with a focus on interdisciplinary actions: street performances, improvisation, installation and workshops. They called it Laboratoire Agit'Art, and its goal was to defiantly challenge the prevailing Négritude philosophy that dominated the country's cultural policies (see pages 32–5). The group was originally based in the Village des Arts in Dakar, a former barracks on the city's seafront, until they were evicted by the military in 1983. They then moved to a courtyard in the Rue Jules Ferry, which belonged to one of Laboratoire Agit'Art's founders, the artist, philosopher and writer Issa Samb.

The aim of the group was to take art out of the institutions – which they believed to be too western focused – and return it to the people. For the protagonists of Laboratoire Agit'Art, culture was a community-based endeavour that could generate vibrant exchanges between practitioners. They rejected the European concept of art as being a solitary experience, arguing that before colonialism, the most popular forms of Senegalese artistic expression had been music, dance, poetry and performance, not the École de Paris-style sculpture and painting as promoted by President Léopold Sédar Senghor's state-controlled policies.

In 1980 Senghor stepped down as president of Senegal, and as a result, many of his enlightened cultural policies were reversed. Laboratoire Agit'Art came under suspicion for its political activism, yet its members continued to operate, participating in touring exhibitions and international biennales until the death of founder Issa Samb in 2017.

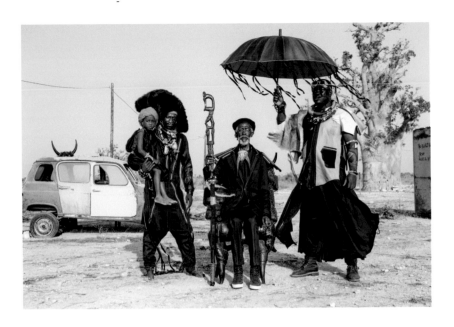

Fabrice Monteiro
*The Missing Link:
Joe*, 2014
Photograph

**Artist Issa Samb is
seated on a carved throne
in this collaboration
with Beninese–Belgian
photographer Fabrice
Monteiro and fashion
label Bull Doff.**

KEY ARTISTS

El Hadji Sy (b.1954), Senegal
Ass M'Bengue (b.1959), Senegal
Issa Samb (1944–2017), Senegal

KEY FEATURES

Collaboration • Happenings • Storytelling and live poetry
• Community works

MEDIA

Performance • Installation • Music • Painting

KEY COLLECTIONS

IFAN Museum of African Arts, Dakar, Senegal
Museum of Black Civilization, Dakar, Senegal
Welkulturen Museum, Frankfurt, Germany

FIGHT CENSORSHIP GROUP
1973–6

Anita Steckel
Nostalgia, Giant Women on New York, 1973
Photo collage and pencil on paper, 37 x 49 cm (14⅜ x 19¼ in.)
Brooklyn Museum, New York

Anita Steckel used the New York skyline as a backdrop for her celebratory images of female sexual exploration.

Anita Steckel never received the recognition she deserved in her lifetime. She was an artist of action, who confronted society's hypocrisies with a razor-sharp humour. Her combative nature often counted against her, and this came to a head in 1973, when attempts were made to censor an exhibition of her photomontages at the Rockland Community College in Suffern, NY. The show was titled 'The Sexual Politics of Feminist Art', and included work from her *Giant Women* series which featured erect penises.

At the time, Steckel was one of a number of women, among them Joan Semmel and Martha Edelheit, who were beginning to represent sex from a female perspective. Steckel's response to attempts by the local authorities to censor the show was to form a feminist group who would fight discrimination against sexual art made by women artists. She sent a letter to the press, announcing her intention and arguing that 'if the erect penis is wholesome enough to go into women – then it is more than wholesome enough to go into the greatest art museums'.

While the controversy was covered in the press, Steckel and many of the artists who had associated themselves with the group continued to struggle for recognition. Their fight, however, came at a critical time, when historians, curators and art critics were re-examining the history of western art and raising questions about female autonomy and how women were objectified and represented in western art.

KEY ARTISTS

Judith Bernstein (b.1942), USA
Louise Bourgeois (1911–2010), France
Martha Edelheit (b.1931), USA
Joan Glueckman (1940–78), USA
Eunice Golden (b.1927), USA
Juanita McNeely (b.1936), USA
Barbara Nessim (b.1939), USA
Joan Semmel (b.1932), USA
Anne Sharp (b.1943), USA
Anita Steckel (1930–2012), USA
Hannah Wilke (1940–93), USA

Joan Semmel
Intimacy-Autonomy, 1974
Oil on canvas, 127 x
248.9 cm (50 x 98 in.)
Brooklyn Museum,
New York

The unusual perspective
of this picture creates
intimacy: the artist's gaze
is merged with that of
the viewer as both are
looking down on the two
bodies from the head
of the bed. The viewer
becomes a participant
in a private moment
between two people.

KEY FEATURE

Sexual and erotic imagery from a female perspective

MEDIA

Oil painting • Collage • Sculpture • Photomontage • Film

KEY COLLECTION

National Museum of Women in the Arts, Washington, DC, USA

INDONESIAN
NEW ART MOVEMENT
1975–88

The Indonesian New Art Movement (Gerakan Seni Rupa Baru) began as a political protest group in 1975, when students from the ASRI Arts Academy in Yogyakarta criticized the jury's selection of paintings at the First Great Exhibition of Indonesian Painting (what is now known as the Jakarta Biennale). The exhibition was supposed to showcase new innovations in art, yet awards had been given to five traditional oil paintings in the decorative Indonesian style. Railing against the art establishment's refusal to recognize the students' conceptual installations, performances and experimentations with materials and styles, they issued a declamatory statement that criticized the art establishment. As a result, several of the artists were suspended from the academy.

Believing Indonesia's art to be too elitist and in thrall to outdated ideas, the students formed the Indonesian New Arts Movement in order to promote an art that traced its roots back to the nineteenth-century modernist Raden Saleh, who embraced radical invention. The group continued to operate on and off throughout the mid-1970s and into the late 1980s during a period when strident criticism of the ruling government was dangerous. They finally disbanded in 1988.

FX Harsono
Paling Top (Top Most),
1975, remade 2006
Plastic rifle, textile,
wooden crate, wire
mesh and LED tube,
156.7 x 99.5 x 50 cm
(61¾ x 39⅛ x 19⅝ in.)
National Gallery
Singapore, Singapore

**Art was deliberately
depoliticized under
President Suharto's
regime, so a conceptual
artwork such as FX
Harsono's, which raised
concerns about the power
of the military in all
facets of Indonesian life,
was particularly risky.**

KEY ARTISTS

Siti Adiyati (b.1951), Indonesia

Hardi (b.1951), Indonesia

FX Harsono (b.1949), Indonesia

Nanik Mirna (1952–2010), Indonesia

Bonyong Munni Ardhi (b.1946), Indonesia

Jim Supangkat (b.1948), Indonesia

KEY FEATURES

Site specific • Text • The use of unusual materials •
Non-narrative structure • Experimental • Transgressive
• Collaboration between artists

MEDIA

Performance • Installation

KEY COLLECTIONS

Asia Art Archive (AAA), Hong Kong, China

Museum Macan, Jakarta, Indonesia

PATTERN AND
DECORATION MOVEMENT
1970s–80s

The Pattern and Decoration Movement was begun in the United States in the late 1970s by a number of abstract painters who had become frustrated by the limitations of abstraction. They also took issue with the idea that pattern and decoration was considered trivial or superficial, and of lower artistic status than other forms of art. As founding member Joyce Kozloff argued, there was 'a third category of art which is neither representational nor abstract'. Through its existence, Pattern and Decoration inadvertently exposed the latent prejudices that underpinned artistic received opinion that the 'high arts' of painting and sculpture were western and male, while the 'low arts' were perceived as African or Oriental and female and somehow intellectually inferior.

Pattern and Decoration raised issues about identity, gender, power and authority, and as a result came to be seen as a feminist movement, which it was in the most part, but it was also trying to obliterate the distinction between art and decoration. The work the group's members produced was visually stunning, and much of their inspiration came from Islamic art, which had a long tradition of pattern and decoration being the highest forms of visual expression. They were also influenced by American folk art and particularly those forms of art that had been considered 'craft', such as quilting, appliqué and collage, and also by the socialist pioneer William Morris and his Arts and Crafts Movement. The group had several shows in the mid-1970s and 1980s that raised questions about the artistic establishment's denigration of artwork that was beautiful or attractive.

Valerie Jaudon
Jackson, 1976
Metallic pigment in polymer emulsion and pencil on canvas, 183.2 x 183.2 cm (72⅛ x 72⅛ in.) Hirshhorn Museum and Sculpture Garden, Washington, DC

Valerie Jaudon looked to highly skilled craft for inspiration, vigorously challenging the conventional belief that patchwork, appliqué and decoupage were not fit for the gallery.

KEY ARTISTS
Cynthia Carison (b.1942), USA
Brad Davis (b.1942), USA
Valerie Jaudon (b.1945), USA
Jane Kaufman (b.1938), USA
Joyce Kozloff (b.1942), USA
Robert Kushner (b.1949), USA
Kim MacConnel (b.1946), USA
Melissa Meyer (b.1946), USA
Tony Robbin (b.1943), USA
Miriam Schapiro (1923–2015), Canada
Ned Smyth (b.1948), USA
Robert Zakanitch (b.1935), USA

KEY FEATURES

Repeating patterns • Ornamentation • Decoration • Bold colour
• Visually stunning • Geometric

MEDIA

Collage • Appliqué • Painting • Patchwork • Textiles

Joyce Kozloff
Hidden Chambers, 1976
Acrylic on canvas, 198.1 x
304.8 cm (78 x 120 in.)
Collection of Françoise
and Harvey Rambach

**In 1978 Valerie Jaudon
and Joyce Kozloff
published a persuasive
document entitled *Art
Hysterical Notions of
Progress and Culture*,
in which they argued
that the entire language
of art needed to be
rewritten by exposing
the latent prejudices
that underpinned artistic
received opinion.**

KEY COLLECTIONS

Hudson River Museum, Yonkers, NY, USA

National Museum of Women in the Arts, Washington, DC, USA

143

THE POLITICS OF ART

-

Continue to make that forbidden deity [riches] your principal one, and soon no more art, no more science, no more pleasure will be possible

-

John Ruskin, 1864

ANTILLES GROUP
1978–83

The black-consciousness art collective the Antilles Group (Grupo Antillano) was founded in Cuba in 1978 by a loose gathering of like-minded Afro-Cuban avant-garde intellectuals who were critical of the island's literary and artistic scene. They were inspired by earlier revolutionary tremors in the Caribbean: notably the anti-colonial Surrealist magazine *Légitime Defense*, which had provoked thought, fermented dreams and encouraged active revolt in the early 1930s, together with the later Négritude Movement which emerged in Paris in 1935. They also looked closer to home, to the painter Wifredo Lam, who had been involved with Négritude, and the revolutionary poet, journalist, activist and ardent *son* dance enthusiast Nicolás Guillén, who had initiated a fusion of black and white Cuban culture in the 1930s and 1940s.

The group members were ideologically driven to create an art and literature that embraced their African heritage, but in the wider context of the Antillean cultural world. Their work incorporated many African aesthetic influences, including folk art, Yoruban

Manuel Couceiro
Untitled, c.1970
Oil on canvas,
107 x 152 cm
(42⅛ x 59⅞ in.)
Private collection

The political activist and painter Manuel Couceiro had also been a member of Fidel Castro's underground 26th of July Movement and had been tortured by the Batista regime.

**Rafael Queneditt
Morales**
Sections of the mural
Mora Abukuá, 1979
Metal
Café Cantante,
Teatro Nacional de Cuba,
Havana

**These metal sculptures
were made by founder
member Queneditt, who
sought a Cuban aesthetic
through traditional
African craftmaking and
geometric abstraction.**

religious symbols and music, although they argued that their object
was not simply aesthetic but to define a Cuban identity. They held
their first exhibition in Havana in 1978 and continued to operate as
a group for another five years before disbanding after accusations
of being counter-revolutionaries. In 2014 interest in the group was
reawakened with an exhibition organized by Alejandro de la Fuente,
entitled 'Drapetomania', revealing their important contribution to
Cuban culture.

KEY ARTISTS
Rogelio Cobas (1925–2014), Cuba
Manuel Couceiro (1923–81), Cuba
Ramón Haití (1932–2013), Cuba
Arnaldo Larrinaga (b.1948), Cuba
Leonel Morales (b.1940), Cuba
Rafael Queneditt Morales (1942–2016), Cuba
Clara Morera (b.1944), Cuba

KEY FEATURES
Folk art • Yoruban religious symbols • Decorative patterns •
Earth tones • Bold colour • Wood • Dreamlike, strange,
uncanny imagery

MEDIA
Sculpture • Painting • Ceramics • Printmaking • Ink drawing

KEY COLLECTIONS
Casa del Caribe, Santiago de Cuba, Cuba
Harvard Fine Arts Library, Cambridge, MA, USA

147

COLLECTIVE FOR
ART ACTIONS
late 1970s–85

Collective for Art Actions (Colectivo de Acciones de Arte; CADA) was a direct action arts collective that gathered force in Santiago in Chile during the brutal regime of General Augusto Pinochet. The coup in 1973 unleashed a reign of terror that lasted for almost seventeen years, with the torture, imprisonment and murder of thousands of dissidents. Such deliberate savagery was feasible only because millions of Chileans were persuaded to believe Pinochet was the only alternative to communism.

To disabuse them of this, artists, writers and theorists came together in the hope that through cultural interventions, rather than politics, they could reveal the corrupt nature of Pinochet's

CADA
¡Ay Sudamérica!, 1981
Gelatin-silver print on
paper, 14 x 18 cm
(5½ x 7⅛ in.)
Museo Nacional Centro
de Arte Reina Sofia,
Madrid

On 12 July 1981 CADA dropped 400,000 leaflets on Santiago de Chile that contained messages of social empowerment and the proposal of a new form of art for the people. The action echoed the brutal bombardment of Salvador Allende's democratically elected government eight years previously, which had led to the establishment of the Pinochet military dictatorship.

government. To do this they needed to establish a new art, one that operated within the parameters of their own history and protected them from censorship and imprisonment. As they said in their 'Declaration of CADA' in 1982, 'Duchamp's premise that art is everything the artist labels as such is not immediately applicable to those whose work defines the terms of their survival (and we mean survival in its most concrete sense) and the fate of their surroundings.'

Some of the artists associated with CADA, which included the visual artists Lotty Rosenfeld and Juan Castillo, as well as the poet Raúl Zurita, the writer Diamela Eltit and the sociologist Fernando Balcells, had previously been involved in creating Agit-prop (overtly political) murals, and they used these experiences to create artworks that encouraged public intervention and disrupted social order. Perhaps the most famous was the political symbol *No +* (meaning 'no more') that they painted across the city, inviting the public to anonymously voice their protest by completing the phrase. It became a powerful anti-Pinochet slogan for much of the 1980s.

KEY ARTISTS
Juan Castillo (b.1952), Chile
Lotty Rosenfeld (b.1943), Chile

KEY FEATURES
Graffiti • Demonstration • Collective action • Socially engaged • Protest

MEDIA
Printmaking • Performance • Collective events • Public artworks • Graffiti

KEY COLLECTIONS
Museo de Arte Contemporáneo, Santiago, Chile
Museo Nacional Centro de Arte Reina Sofia, Madrid, Spain

MINJUNG ART MOVEMENT
1980s

Minjung misul (People's Art) describes the grass-roots cultural
movement that emerged as part of a wider political movement
in South Korea in the 1980s in protest against the country's
authoritarian regime. In 1979 President Park Chung Hee was
assassinated and military rule was established, sparking nationwide,
pro-democracy demonstrations. The unrest came to a head in 1980
in a small southwestern city province where dissidents were injured
and killed in clashes with the military. It became known as the
Gwangju Massacre.

Out of this turmoil came a raw and urgent political culture:
writers, theorists, filmmakers, theatre practitioners and artists
became activists, keen to create a new, anti-imperialist modern
art that was rooted in the social conditions of everyday life. They
drew aesthetic inspiration from Africa, Asia and Latin America,
and worked with materials that could be easily disseminated such
as posters, banners and photography. The Reality and Utterance
Group used art to express political messages, while the feminist
collective Dung-Ji raised awareness about the lives of women in
modern Korea.

Although there was no definitive style, much of the art made at
the time looked to traditional folk art and woodcuts and embraced
peasant culture. The key was that art should engage with and speak
for a society confronted by the enormities of rapid industrialization.
Today, Gwangju is home to an art biennale, and its ideals were
founded in accord with the democratizing ideals of the Minjung
Art Movement.

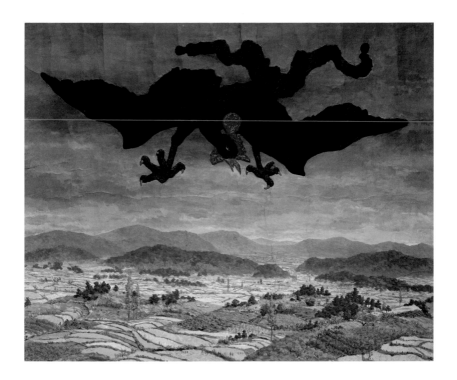

Lim Ok-Sang
Black Bird, 1983
Acrylic on paper, 215 x
269 cm (84⅝ x 105⅞ in.)
Samsung Museum of Art,
Seoul

For almost a decade Lim
Ok-Sang was blacklisted
by the authorities owing
to the political content
of his work. Made in
the aftermath of the
Gwangju Massacre in
1980, the bird could
represent the malfeasant
force of the ruling elite
or the encroachment of
industrialization on the
countryside.

KEY ARTISTS

Hong Song-Dam (b.1955), South Korea
Kim Jung-Heun (b.1946), South Korea
Lim Ok-Sang (b.1950), South Korea
Oh Yoon (1946–86), South Korea

KEY FEATURES

Realism • The representation of life experiences of middle- and
working-class people • Reportage • Plain, communicative style •
Protest • Outdoors and available to the public • Socially engaged
• Collaboration

MEDIA

Printing • Photography • Video • Film • Woodcut

KEY COLLECTIONS

Seoul Museum of Art, Seoul, South Korea

BRITISH BLACK ARTS
MOVEMENT
1980s

The British Black Arts Movement has come to describe a period of intensive creative activity that occurred in the 1980s among artists of African and Asian descent. The movement had been gathering force in Britain since the 1950s, when migrants from the Asian subcontinent and the African diaspora restless for artistic recognition came to the country – their work motivated by the anti-colonial struggle for independence.

By the 1980s these artists were joined by a younger, British-born generation who were actively involved in the powerful grassroots mobilization against racism in the country (during a time of race riots in many cities across Britain).

While the two generations had different perspectives, the result was a vibrant period of art from the most marginal spaces. Debates, political action and exhibitions confronted issues around discrimination, alienation, social justice and identity. Inspiration was taken from anti-colonial writers such as Amilcar Cabral and Frantz Fanon and conferences were organized, most significantly the inaugural National Black Art Convention at Wolverhampton Polytechnic in 1982.

Eddie Chambers
Destruction of the National Front, 1979–80
Four screenprints on paper on card,
82.7 x 239.2 cm
(32½ x 94⅛ in.)
Tate, London

Chambers tore up an image of the Union Jack and reconstructed it into the shape of a swastika, which he then deconstructed over four panels until it was no longer recognizable. It was made at a time when the far-right National Front had a strong presence in Chambers' home city of Wolverhampton in the West Midlands.

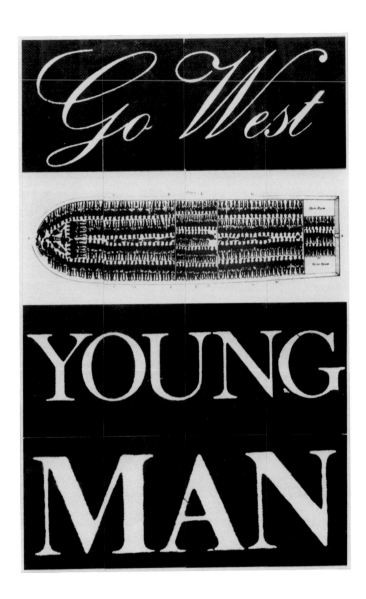

Keith Piper
Go West Young Man, 1987
Gelatin-silver print on
paper mounted onto
board, 84 x 56 cm
(33⅛ x 22 in.)
Tate, London

Piper's multipanelled
collage of family
snapshots, film stills
and historical documents
reflects on the history
of the black male body
from slavery to the
present day.

153

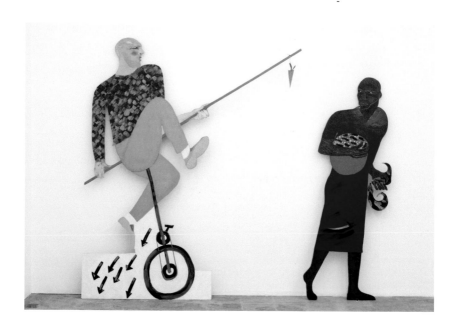

The BLK Art Group was founded by, among others, Keith Piper, Eddie Chambers and Claudette Johnson and the Black Audio Film Collective by John Akomfrah. An exhibition of 'Five Black Women', organized by the artists Sonia Boyce, Lubaina Himid, Claudette Johnson, Houria Niati and Veronica Ryan, also raised issues about the tensions that existed between the sexes. The body became a place in which to explore the complexities of being black, identified by Fanon as 'the fact of blackness', by artists like Mona Hatoum who also critically challenged the Eurocentrism of British art schools. The movement continued until the early 1990s, when Thatcherite policies and the rise of the commercial art gallery led the art world away from urgent political art.

Lubaina Himid
The Carrot Piece, 1985
Acrylic on wood, card
and string, 243 x 335 cm
(95⅝ x 131⅞ in.)
Tate, London

A white man tries to tempt a black woman with a carrot. Himid made the work in response to what she saw as patronizing approaches by the art establishment to minority groups.

KEY ARTISTS
John Akomfrah (b.1957), UK
Sutapa Biswas (b.1962), UK
Sonia Boyce (b.1962), UK
Eddie Chambers (b.1960), UK
Lubaina Himid (b.1954), UK
Keith Piper (b.1960), UK
Donald Rodney (1961–98), UK
Marlene Smith (b.1964), UK

KEY FEATURES

Using images from the mass media and pop culture to explore issues of racial identity and racism • Memory • Loss • Transnationalism • The body

MEDIA

Collage • Painting • Video • Mass media • Photography • Installation • Sculpture

KEY COLLECTIONS

Arts Council Collection, London, UK

BLK Art Group Archive (online)

Tate, London, UK

Sonia Boyce
Missionary Position, 1985
Watercolour, pastel
and crayon on paper,
123.8 x 183 cm
(48¾ x 72 in.)
Tate, London

This painting explores the role of religion in British society across different cultures and generations. The figure on the right is wearing a red turban which could be associated with Rastafarianism, while the praying figure represents Christianity.

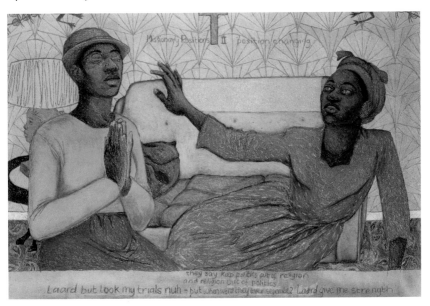

85 ART MOVEMENT
1984–9

85 Art Movement was a catch-all term coined by the artist Wang Guangyi in 1986 to describe a vibrant period of nonconformist art in China in the mid-1980s that accompanied the influx of western culture and liberal ideas when the Chinese premier Deng Xiaoping initiated the Open Door Policy in 1978. Between 1984 and 1986 it is thought that some eighty collectives and societies of mainly young art school graduates emerged across China.

During the Cultural Revolution (1966–76), many art schools in the country had been closed down and the only acceptable form of art had been Socialist Realism. Now, with the slight relaxation of cultural censorship, art schools had reopened, and students were keen to develop a form of Chinese modernism that would examine the relationship between art and society and create some form of metaphysical transcendence.

Although there was no cohesive aesthetic style or theory, artists of the 85 Art Movement were interested in avant-garde western ideas, in particular Kant, existentialism, Dada and Surrealism. Some of the most prominent groups were the Red Brigade, Northern Art Group, Pond Association, Southwest Art Research Group, Xiamen Dada and the Southern Artists Salon. These groups were also emerging at a time of rapid industrialization in the country, and they used their art to raise concerns about the impact on the

Song Ling
Pipeline No. 4, 1985
Ink on paper, 148 x
90 cm (58¼ x 35⅜ in.)

Founding member of the Pond Association, Song Ling combined a propaganda-poster aesthetic with Surrealism to create a series of paintings called *Pipelines* that critiqued the alienation of the Chinese people through industrialization.

environment. This period of exuberant activity came to an end in 1989, after the Tiananmen Square Massacre, when unauthorized public events (such as exhibitions and performances) were banned.

KEY ARTISTS

Huang Yongping (b.1954), China
Song Ling (b.1961), China
Wang Du (b.1956), China
Wang Guangyi (b.1957), China
Zhang Peili (b.1957), China
Zhang Xiaogang (b.1958), China

Wang Guangyi
Red Rationality:
Revision of Idols, 1987
Oil on canvas, 200 x
160 cm (78¾ x 63 in.)
Private collection

KEY FEATURES

Collective actions • Existentialist • Metaphysical • Experimental • Humanist • Rational • Keen interest in environment and beauty

MEDIA

Painting • Sculpture • Site-specific installation • Video • Performance

Wang was a member of the influential Northern Art Group. In the 1980s he set out to radically question traditional compositional forms in art. Here, he has stripped back the classical *pietà* and concealed it behind a red grid.

KEY COLLECTIONS

Guggenheim Collection, New York, NY, USA
M+ Sigg Collection, Hong Kong, China
Museum of Modern Art (MoMA), New York, NY, USA

KERALA RADICALS
1987–9

The Kerala Radicals, also known as the Radical Painters and Sculptors Association, was a short-lived anti-commercial collective of south Indian artists who came together from 1987 to 1989 to promote their vision of a socially conscious form of art for the people.

Many of the artists came from Kerala, where an atmosphere of revolutionary Marxist ideology had existed since the early 1970s emboldened by resistance to Prime Minister Indira Gandhi's policies. Led by the high-strung idealist K. P. Krishnakumar, the group rejected the art of previous modernists such as those of the Bengal School (see pages 10–13) and drew inspiration from German Expressionism, in particularly Käthe Kollwitz, and other subversive European artists who highlighted the marginalization and oppression of the poor in early twentieth-century art.

The artists had their first exhibition in Vadodara in Gujarat in 1987, where Krishnakumar was studying at the Faculty of Fine Arts, Maharaja Sayajirao University. The group then relocated to Kerala, where they established studios and held community workshops and debates. While they did not have a singular aesthetic identity, there was a certain sense of existential crisis about the art

K. P. Krishnakumar
The Thief, 1985
Painted fibreglass,
153 x 92 x 61 cm
(60¼ x 36¼ x 24 in.)
Kasauli Art Centre,
Kasauli

Krishnakumar used cheap materials like cloth, plaster and enamel and created sculptures that were rough, distorted and reminiscent of a universal folk-art in order to avoid any kind of Orientalist reading of his artwork.

they made, and they were openly critical of traditional art made for western consumption.

The Radicals continued to operate for the next two years, until Krishnakumar's idealism began to cause problems among the members and the group disintegrated. Krishnakumar sadly committed suicide in 1989.

KEY ARTISTS

Jyothi Basu (b.1960), India
Anita Dube (b.1958), India
K. P. Krishnakumar (1958–89), India
K. M. Madhusudhanan (b.1956), India
K. Raghunathan (b.1958), India

KEY FEATURES

Figurative • Expressive brushstrokes • Emotional • Political • Experimental • Rough surfaces • Rich enamel colours • Heroic or fateful characters

MEDIA

Clay • Painting • Fibreglass • Sculpture

KEY COLLECTIONS

Devi Art Foundation, New Delhi, India
Kiran Nadar Museum of Art, New Delhi, India
Peabody Essex Museum, Salem, MA, USA

USEFUL ART MOVEMENT
1999 onwards

Marcus Coates
Journey to the Lower World (Beryl), 2004
Archival inkjet print, 115 x 115 cm (45¼ x 45¼ in.) of a performance, digital video 28:13 min

In 2004 Marcus Coates performed a traditional Siberan Yakut ritual for a group of residents of a condemned tower block in Liverpool, who were anxious about what would happen to them after the building was demolished.

The philosophy of the Useful Art Movement is partly inspired by the reformist ideals of the nineteenth-century British theorist John Ruskin, who argued that art and beauty were integral to ordinary life and without them society could not flourish. Central to his writings was the belief that societies founded on heartless structures, such as capitalism, treat people and the environment brutally, creating extreme inequality, aesthetic impoverishment and ecological ruin.

For many years, Ruskin lived at Brantwood in Coniston in the Lake District, which is now the centre of the Useful Arts Movement run from the rural arts institution, Grizedale Arts. The philosophy was established by the directors Adam Sutherland and Alistair Hudson together with the Cuban artist activist Tania Bruguera, who later wrote a manifesto in which she sought to articulate how artists could be active and socially engaged citizens in the modern world. Bruguera also drew on the conceptual writings and interventions of the Argentinian artist Eduardo Costa, who developed Arte Util in the 1960s, in which he used his art to help society and combat repression and censorship.

In 2012 Grizedale Arts and the artist Marcus Coates curated a show at Jerwood Visual Arts called 'Now I Gotta Reason' that

Marcus Coates
Journey to the Lower World (CCTV Lift), 2004
Archival inkjet print, 115 x 115 cm (45¼ x 45¼ in.) of a performance, digital video

The residents of a condemned block of flats in Liverpool asked the question: 'Do we have a protector for this site, and what is it?' Coates consulted animal spirits and performed a ritual in which he uttered strange feral sounds. Traditionally shamans were used to solve everyday problems in close-knit communities.

Grizedale Arts
*Colosseum of the
Consumed*, 2012
Temporary structure,
Frieze Art Fair,
London 2012

**For Frieze Art Fair,
Grizedale Arts
constructed a timber
structure modelled
as a cross between a
Roman amphitheatre
and a cricket pavilion,
in which they presented
a series of food-related
performances and
discussions about
sustainability and the
high-cost production
of food.**

Tania Bruguera
Immigrant Movement
International, 2011
Photograph
Queens, New York, NY

**Established in 2011, the
Immigrant Movement
International addresses
the needs of immigrants
across the world. These
women are participating
in a cultural initiative
in Corona, Queens,
New York, NY, where
the movement has
organized language
classes, workshops and
access to immigration
lawyers for residents.**

brought international artists together who focused on the creation of art as a useful and productive activity.

Projects that are associated with the Useful Art Movement include the Immigrant Movement International, which Bruguera began in order to raise the visibility of immigrants and give them access to political power. Other initiatives include the Shepherd School in the Urrielles Mountains, set up by the Spanish artist Fernando García-Dory in order to save a dying profession, and the Fairland Collective, who engage communities through everyday activities. In 2017 Grizedale Arts established the Confederacy of Villages, in which small communities across the world sharing similar concerns such as affordable housing and an aging population connect in order to solve their problems creatively.

KEY ARTISTS
Tania Bruguera (b.1968), Cuba
Marcus Coates (b.1968), UK
Fernando García-Dory (b.1978), Spain
Niamh Riordan (b.1986), UK
Adam Sutherland (b. 1958), UK
Francesca Ulivi (b.1990), Italy

KEY FEATURES
Working with traditional skills and materials • Working with power structures • Community engagement • Participatory • Performance • Workshop based • Working with the environment • An interest in ecology

MEDIA
Traditional crafts and skills • Performance • Sculpture • Video • Pottery • Printmaking

KEY COLLECTIONS
Grizedale Arts, UK
Tate Collection, London, UK

BLACK LIVES MATTER
2012 onwards

Black Lives Matter (BLM) emerged as a grassroots protest group in the United States in 2012 in the wake of a number of murders of unarmed black teenagers. Co-founded by artist Patrisse Cullors, activist Alicia Garza and writer Opel Tometi, it is now a global social movement that works to highlight racial inequality, police brutality and violence against black people. Unlike previous civil rights groups, BLM is nonhierarchical; there is no figurehead – its philosophy being that 10,000 candles are better than a single spotlight.

The organization reaches its audience via social media, encouraging its supporters to document their own experiences of brutality and harassment. BLM first came to wider prominence in 2013 with a protest in Ferguson, Missouri, following the killing of eighteen-year-old Michael Brown by a police officer. Over the years it has also become a voice for other marginalized groups, raising issues around workers' rights and gender and sexual equality.

Since its inception, BLM has worked alongside a number of artists and cultural commentators to promote its activist agenda. Most notably it has colloborated with the collective Black Women Artists for Black Lives Matter, who stage performances, workshops and public programming events highlighting the cause. Other prestigious artworks have included a project by artist Adam Pendleton, part of which was to fly a BLM flag and cover a wall in the Belgian Pavilion at the 2015 Venice Biennale with the statement 'Black Lives Matter'. He described the words at the time as 'a rallying cry and a poetic plea for justice'. Artist Kara Walker has also referenced the movement in her racially charged paintings and installations that explore the history of violence towards black people and of slavery in the United States.

In 2018 BLM launched Black Lives Matter Arts+Culture in order to promote African-American artists who are using art to support social change and provide a much-needed space for artists and designers of colour.

Adam Pendleton
Black Dada Flag (Black Lives Matter), 2015–18
Digital print on polyester,
182.9 x 274.3 cm
(72 x 108 in.)
Frieze New York 2018,
Randall's Island Park,
New York

Pendleton's ongoing project *Black Dada Flag* has been used internationally to open up conversations about the role of art in political debate.

Overleaf: Emory Douglas
Front and back covers
of *The Black Panther*,
21 August 1971
Offset lithograph on
paper, 44.5 x 58 cm
(17½ x 22⅞ in.)
Center for the Study
of Political Graphics,
Los Angeles

**Activist artist Emory
Douglas was the minister
for culture in the Black
Panther Party and was
responsible for the
striking images that came
to represent the cause.
He purposely used simple
graphic images – thick
lines and single colours
– that could be printed
and distributed cheaply.
Douglas was the first
artist to be featured on
the BLM Arts+Culture
platform.**

KEY ARTISTS

Patrisse Cullors (b.1984), USA

Emory Douglas (b.1943), USA

Tomashi Jackson (b.1980), USA

Simone Leigh (b.1968), USA

Adam Pendleton (b.1984), USA

Kara Walker (b.1969), USA

KEY FEATURES

A concern with black culture and identity • An assertion of a
black presence in what had previously been considered to be
white western territory • Addresses racism

MEDIA

Painting • Sculpture • Performance • Installation • Film
• Digital • Collective actions and public artworks

KEY COLLECTIONS

Archive for Black Lives (online)

Museum of Modern Art (MoMA), New York, NY, USA

National Museum of African American History and Culture,
 Washington, DC, USA

Tate, London, UK

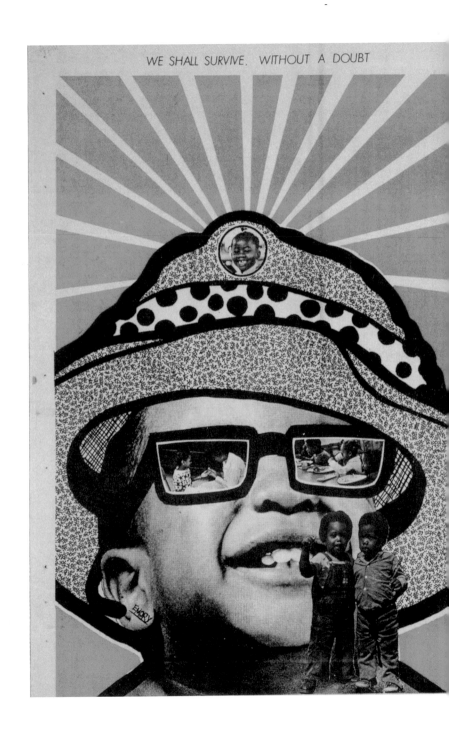

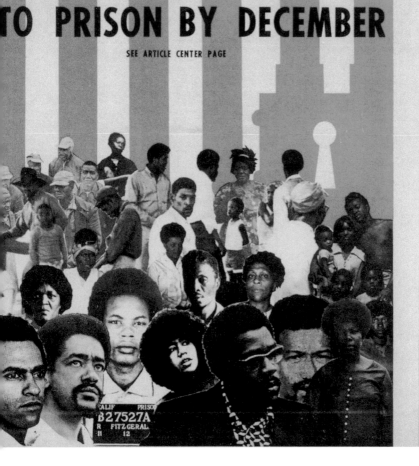

GLOSSARY

Anti-art: a term used to challenge the existing structures of traditional art –the way it is made, the materials used and how it is presented.

Appliqué: a technique in which a cut-out decoration is sewn onto another piece of fabric.

Art deco: a style that emerged in Europe in the mid-1920s as a successor to art nouveau. It was geometric in character, having been inspired by Cubism and artefacts from ancient civilizations such as Egypt.

Art Informel: a highly gestural form of abstract painting that combined paint with other materials, including detritus.

Artist manifesto: written document outlining an artist's or artists' philosophy and intentions which is distributed publicly. They can take many forms – flyers, pamphlets, personal manuscripts, *samizdat* typescripts, postcards, poems and performances.

Art nouveau: an international modern art movement that emerged in Europe and the USA in the 1880s with a focus on bold line rendered simply. The style was partly inspired by Japanese art, Gothic architecture and Anglo-Saxon design.

Arte Povera: radical and experimental art form that emerged in Italy in the 1960s. It was anti-capitalist and used everyday (poor) materials that could be sourced by anyone.

Avant-garde: from the French for vanguard, meaning ahead of one's contemporaries – experimental, innovative and revolutionary.

Civil rights movement: a black consciousness movement that emerged in the United States in the 1950s in order to fight for equal rights for African-Americans. Its most famous advocate was Martin Luther King.

Conceptual art: art focusing on ideas or processes rather than a finished object; it gained traction in the 1960s.

Concrete Art: an art that is not representative of anything and has no symbolic meaning. It is simply a composition of lines, colours and shapes.

Concrete Poetry: a visual form of poetry – often using text that is arranged into an image.

Constructivism: an abstract art movement based on the use of geometric shapes, founded in Russia in about 1913.

Cubism: a pictorial style invented in the early twentieth century by Pablo Picasso and Georges Braque, in which an image is shown from different viewpoints at the same time, resulting in a complex, fragmentary picture.

Dada: a highly influential artistic and literary movement founded in Zurich and New York in 1916 in reaction to the horrors of the First World War. Those associated with it created nonsensical poetry and satirical art – much of its visual material was made from collage.

Decoupage: the technique of using paper cut-outs to decorate objects, from the French word *découper*, meaning to cut out.

Degenerate Art: a term used to describe all modern art that was deemed unacceptable by the Nazi party in Germany in 1937. They were particularly offended by Expressionism and some 15,500 works were removed from museums and galleries.

Expressionism: a movement mainly centred in Germany in the early twentieth century. Expressionism used strong colours, distorted forms and fierce brushwork to express the artists' inner feelings.

Fauvism: a movement that emerged in Paris at the turn of the twentieth century. It was characterized by strong colours and expressive brushwork. Its major proponents were Henri Matisse and André Derain.

Fluxus: founded in the 1960s by George Maciunas, Fluxus was an international movement of artists, musicians and performers who believed in a democratic living art based on experimentation.

Happening: an action undertaken by an individual or a collective, often in public, that is performative and can involve an element of

spectator participation. The term was first used by the American artist and lecturer Allan Kaprow in 1959.

Kālīghāt painting: a style of painting, distinguished by its use of bold outlines and bright colours, that emerged in Kolkata in West Bengal in the nineteenth century.

Metaphysical painting: a movement that emerged in Italy in the early twentieth century that is noted for its dreamlike visions of empty spaces and strange objects. It was influential in the development of Surrealism and its main proponent was Giorgio de Chirico.

Négritude: a philosophy conceived by a group of Surrealist poets from the African diaspora (Aimé Césaire, Léopold Sédar Senghor and Léon-Gontran Damas) that sought to reclaim the value of blackness and African culture.

Nonconformist Art (Soviet): art made in the USSR between 1953–89 that was not Socialist Realist and not sanctioned by the state.

Pan-Africanism: an ideology based on the cultural unification of Africa and its diaspora.

Pan-Arabism: an ideology based on the cultural unification of the Arab-speaking world.

Pan-Asian: an idealogy based on the cultural unification of Asian people.

Performance art: a form of living art that emerged in the 1950s, in which the artist uses their body or the bodies of the audience to create an action or a Happening.

Plastic arts: a term used to describe an artwork made by sculpting or modelling a material into a three-dimensional object.

Pre-Columbian art: visual art made in the Caribbean and Central and South America before the arrival of Christopher Columbus in 1492.

Samizdat: a term that emerged in Eastern Europe that refers to a document that is distributed clandestinely in places where there is totalitarian censorship.

Social Realism: a style of painting that carries a political or social message.

Socialist Realism: a form of modern realism imposed in the USSR by Stalin in the late 1920s. It is identified by optimistic depictions of Soviet life painted in a realist style.

Super-real: a term coined by the African-American art movement AfriCOBRA in the 1960s to describe their heightened form of Surrealism. It was characterized by acid bright colours, unstructured symmetry, music, fashion and art from Africa.

Surrealism: a cultural movement from the mid-twentieth century that was interested in dreams, the unconscious and the uncanny.

Symbolism: an international movement that began in France in the late 1880s that focused on the inner world rather than the exterior world. Paintings evoked moods and emotions, dreamlike imagery and mystical experiences, with the goal of creating a psychological impact.

Taoism: a philosophy that advocates living in harmony with nature. It originated in ancient China.

Transnationalism: a concept that relates to the way cultures, nations, race and groups have interacted, collided and blended throughout time.

Tropicália: a playful and experimental art movement that emerged in Brazil in the late 1960s. It challenged the political and cultural dominance of the United States, ushering a new era of Latin American artists, filmmakers and and musicians.

INDEX OF CULTURAL PROTAGONISTS

Illustrations are in *italics*

PICTURE ACKNOWLEDGEMENTS

a above **b** below

2 Private collection; **10** National Gallery of Modern Art, New Delhi. akg-images/Album; **13** Private collection; **14** Brooklyn Museum of Art, New York. Emily Winthrop Miles Fund/Bridgeman Images. Mendez © DACS 2020; **15** Private collection; **16** Private collection; **18** Museum of Contemporary Art, Zagreb; **19** Private collection; **20** Museo Nacional de Bellas Artes de Cuba, Havana; **23** Digital image, The Museum of Modern Art, New York, NY/ Scala, Florence. © Amelia Pelaez Foundation; **24** Private collection. Photo Christie's Images/Bridgeman Images; **26** National Museum, Beijing. akg-images. Hua © DACS 2020; **27** Lu Xun Museum, Shanghai. akg-images; **29** Museu de Arte São Paulo Assis Chateaubriand. Photo João Musa. Di Cavalcanti © DACS 2020; **30** Musée de Grenoble, France. © Tarsila do Amaral Lic; **32** Private collection. Michael Graham-Stewart/Bridgeman Images; **35** Musée national d'art moderne, Paris. Lam © ADAGP, Paris and DACS, London 2020; **36** Al Thani Collection, Doha; **37** Christophe Bouleau & Lucie Thiam; **39** Al Thani Collection, Doha; **40** Private collection. Photo Christie's Images/Bridgeman Images; **42** Digital image, The Museum of Modern Art, New York/Scala, Florence; **45** Courtesy Ignacio Pedronzo, Sammer Gallery Miami; **48** Janus Pannonius Museum, Pecs/Ferenczy Museum, Szentendre. Anna © DACS 2020; **50–51** Private collection. Lossonczy © DACS 2020; **52–3** Private collection. Photo Christie's Images/Bridgeman Images; **54** Tate, London. © Estate of F N Souza. All rights reserved, DACS 2020; **56, 58–9** Courtesy of Barjeel Art Foundation, photographed by Capital D; **60** Tate, London. © Ibrahim El-Salahi. All rights reserved, DACS 2020; **63** Museum of Contemporary Art, Tokyo. © Tatsuo Ikeda; **64–5** Taro Okamoto Museum of Art, Kawasaki; **66, 67** © Seiko Otsuji, Musashino Art University Museum & Library/Courtesy of Tokyo Publishing House. From the portfolio 'eyewitness'; **69** Private collection. Photo Christie's Images/Bridgeman Images. Zenderoudi © ADAGP, Paris and DACS, London 2020; **71** National Museum of African Art, Smithsonian Institution, Washington, DC; **72** Private collection; **74–5** Private collection; **78** Mercantil Arte y Cultura, Caracas; **80** Museum of Avant-Garde, Zagreb. Knifer © ADAGP, Paris and DACS, London 2020; **81** Digital image Museum of Modern Art, New York, NY/Scala, Florence. Ivan Picelj Estate; **82** © Lev Nussberg Archive, Orange, CT; **85** Cleveland Musem of Art, Ohio. © Emma Amos/VAGA at ARS, NY and DACS, London 2020; **86–7** Milwaukee Art Museum. © Romare Bearden Foundation/VAGA at ARS, NY and DACS, London 2020; **88** Digital image, Museum of Modern Art, New York/Scala, Florence. Knížák © DACS 2020; **90** Courtesy of the artist and Moderna galerija, Ljubljana; **92** Roberto Jacoby Archives, Buenos Aires; **94** Cooper-Hewitt, Smithsonian Design Museum/Art Resource, New York, NY/ Scala, Florence; **97** Tate, London. © The Ronald Moody Trust; **99** AFP/Getty Images; **100a** Helinä Rautavaara/Helinä Rautavaara Museum; **100b** Photo Karega Kofi Moyo/Getty Images; **102** Toyota Municipal Museum of Art, Tokyo. © The Estate of Jiro Takamatsu, Courtesy Yumiko Chiba Associates/Stephen Friedman Gallery/Fergus McCaffrey; **104** © Susumu Koshimizu, Courtesy of the artist and Blum & Poe, Los Angeles, CA/New York, NY/Tokyo; **105** © Nobuo Sekine, Courtesy of the artist and Blum & Poe, Los Angeles/New York/Tokyo. Photo: Joshua White; **106, 107** Photo Robert Abbott Sengstacke/Getty Images; **108–9** Courtesy of Michael Rosenfeld Gallery LLC, New York, NY; **112** Archives Denis Martinez; **114** Courtesy of Misa Shin Gallery; **115** © HORI Kosai, Courtesy of the artist and Mizuma Art Gallery; **116** Brooklyn Museum, New York. © Estate of Barbara Jones-Hogu/Courtesy Lusenhop Fine Art; **117, 118** Courtesy of the artist and Kavi Gupta; **119** Courtesy Kravets Wehby Gallery and the Estate of Jeff Donaldson; **120** Courtesy of Barjeel Art Foundation, photographed by Capital D; **121** Private collection; **123** © Guy Le Querrec/Magnum Photos; **124** Courtesy the artist and Ronald Feldman Gallery, New York, NY; **125** © Irina Nakhova; **127** Courtesy of Andrei Monastyrski. Photo G. Kizevalter; **129** Private collection. Christie's Images, London/Scala, Florence. Ufan © ADAGP, Paris and DACS, London 2020; **131** © Kwon Young-woo. Courtesy of the Estate of Kwon Young-woo and Blum & Poe, Los Angeles/New York/Tokyo; **133** Courtesy the artist; **134** Brooklyn Museum, New York. Photographer Jason Mandella. Courtesy of Suzanne Geiss, New York. © Anita Steckel; **136–7** Brooklyn Museum, New York. © ARS, NY and DACS, London 2020; **138** Collection of National Gallery Singapore; **140** Hirshhorn Museum and Sculpture Garden, Washington, DC © Valerie Jaudon/VAGA at ARS, NY and DACS, London 2020; **142–3** Courtesy of the artist and DC Moore Gallery, New York, NY; **146** Private collection; **147** Teatro Nacional de Cuba, Havana; **148** Photographic Archives Museo Nacional Centro de Arte Reina Sofia, Madrid; **151** Samsung Museum of Art, Seoul; **152, 153** Tate, London; **154** Tate Collection. Courtesy the artist and Hollybush Gardens. Photo Andy Keate; **155** Tate, London. © Sonia Boyce. All Rights Reserved, DACS 2020; **156** © the artist; **157** Private collection. Wang Guangyi Studio; **158** Kassauli Art Centre. Vivan Sundaram and Asia Art Archive; **160, 161** Photography by Nick David; **162a** Grizedale Arts; **162b** Creative Time, New York. Bruguera © ARS, NY and DACS, London 2020; **165** © Adam Pendleton, courtesy Pace Gallery. Photography by Guy Ben-Ari; **166–7** Center for the Study of Political Graphics, Los Angeles, CA. © Emory Douglas/DACS 2020.

-

To the unsung
and the overlooked

-

Global Art © 2020
Thames & Hudson Ltd, London

Text © 2020 Jessica Lack

Design by April
Edited by Caroline Brooke Johnson

First published in 2020 in the
United States by Thames & Hudson
Inc., 500 Fifth Avenue, New York,
New York 10110

www.thamesandhudsonusa.com

Library of Congress Control
Number 2019947727
ISBN 9780-500-29524-3

Printed and bound in China by
Toppan Leefung Printing Ltd

Front cover: Boula Heinen, Photograph of Georges Heinen, date unknown. © Catherine Farhi

Title page: Papa Ibra Tall, *The Warrior*, 1964. Private collection (detail from page 72)

Chapter openers: page 8 Li Hua, *China, Roar!*, 1935 (detail from page 26). National Museum of China, Beijing; **page 46** Jewad Selim, *Woman Selling Material*, 1953. Barjeel Art Foundation, Sharjah (detail from page 56); **page 76** Romare Bearden, *The Street*, 1965. Milwaukee Art Museum, Milwaukee (detail from pages 86–7); page 110 Wadsworth Jarrell, *I Am Better than Those Motherfuckers and They Know It*, 1969 (detail from page 118). Studio Museum, Harlem, New York, NY; page 144 Song Ling, *Pipeline No. 4*, 1985 (detail from page 156).

Quotations: page 9 'Manifesto of the Storm Society', translated by Michael Fei, *Yishu xunkan* (art journal), vol. 1, no.5, October 1932; **page 47** André Breton, 'What is Surrealism?', lecture delivered in Brussels, Belgium, 1 June 1934; **page 77** Andrei Tarkovsky, from the documentary *A Poet in the Cinema*, 1983; **page 111** Richard Wright, *12 Million Black Voices* (Viking, London, 1941); **page 145** John Ruskin, 'Traffic', lecture given at Bradford Mechanics' Institute, 21 April 1864 (first published 1866)

Note to reader
In China, Japan and Korea the family name comes before the given name. The eastern way has been used in the key artist lists in this book. It is, however, not uncommon for artists' names to be westernized, with the given name coming first.